Lost Motels
OF
GATLINBURG

Lost Motels
OF
GATLINBURG

BRIAN M. McKNIGHT
FOREWORD BY TIM HOLLIS

THE
History
PRESS

Published by The History Press
Charleston, SC
www.historypress.com

Copyright © 2024 by Brian M. McKnight
All rights reserved

First published 2024

Manufactured in the United States

All images courtesy of the author's collection unless otherwise noted.

ISBN 9781467156387

Library of Congress Control Number: 2023950632

Notice: The information in this book is true and complete to the best of our knowledge. It is offered without guarantee on the part of the author or The History Press. The author and The History Press disclaim all liability in connection with the use of this book.

All rights reserved. No part of this book may be reproduced or transmitted in any form whatsoever without prior written permission from the publisher except in the case of brief quotations embodied in critical articles and reviews.

To the most radiant flowers in my world: my beloved wife, Heather, and our precious baby daughter, Dahlia.

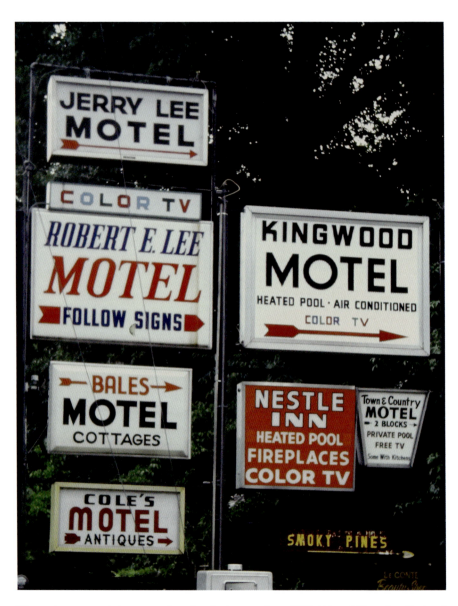

These vintage motel signs, once found at the intersection of US 441 and Cherokee Orchard Road, sum up the essence of *Lost Motels of Gatlinburg*, as each advertised location has, sadly, closed its doors.

Contents

ACKNOWLEDGEMENTS	9
FOREWORD	11
INTRODUCTION	13
1. THE PARKWAY	15
2. AIRPORT ROAD	63
3. RIVER ROAD	81
4. HIGHWAY 73	89
5. BASKINS CREEK AND BEYOND	119
BIBLIOGRAPHY	153
ABOUT THE AUTHOR	155

Acknowledgements

The people I met and interviewed during this journey, some of whom have become great friends, will remain an invaluable treasure in my life. I'd like to acknowledge them, because this volume wouldn't have been possible without their help. So, without further ado, here are the incredible individuals who made this book a reality: Robin Whaley Andrews, Adam Jack Arthur, Stephen Lyn Bales, Doug BeVille, Laura BeVille, Nancy Trentham Bohanan, Betsy Cate, Todd Carver, Gary Clabo, Karen Clabo, Keith Cox, Clella Ann Dixon, Benjamin Goldberg, Lindsay Gregg, Margery Helms, Susan Helms, Joy Jucker, Veta King, Joan A. King, Mark Lancaster, Jeff Leazer, Brandon Lunsford, Gary McKay, Carroll McMahan, Karen Huskey McReynolds, Carolyn Merritt, Beau Miller, Ed Ogle, Luann Sutton Ogle, Kathy Olivo, Andrew Oxenham, Norman Porter, Jerry Rawlings, Dennis Reagan, Lee Reagan, Lori Lovsey Reagan, Mark Reagan, Orville Von Reagan Jr., Stephanie Reagan, Frances Fox Shambaugh, Craig Trentham, Roger Trentham, Nicholas Voyles, Steve Whaley, Ray Whaley.

In addition to the folks mentioned above, I also want to express my deepest gratitude to my dear friend and author Tim Hollis. He provided invaluable guidance throughout this process but also the wonderful foreword for the book. Thanks so much, Tim!

I am also incredibly grateful to my friend Randy Trentham, whose extensive knowledge of the area proved to be indispensable. I hope our conversations continue long after the book's publication.

ACKNOWLEDGEMENTS

Last, but certainly not least, I want to dedicate a special mention to my wife, Heather McKnight. Her unwavering support, countless hours of help with rewrites and grammar and tireless dedication to research made this book a true labor of love for both of us. I love her beyond measure, and this volume is as much hers as it is mine.

Foreword

Howdy, folks! Surprised to see me here, in someone else's book? Well, you shouldn't be, as I've been asked to do this sort of thing before. I am pleased to lead you into my colleague Brian McKnight's journey along the crowded highway (US 441, mainly) of Gatlinburg motels—and friends, there were lots and lots of them.

As chronicled in several of my own books (*Lost Attractions of the Smoky Mountains* being one of the most recent), the area around Gatlinburg was stuffed with every possible—and sometimes impossible—type of attraction. But what I did not cover deeply is that for every attraction such as Jolly Golf, Ripley's Believe It or Not! Museum or the Space Needle, there were at least two—no, make that three—maybe it was closer to four—motels to serve the visitors who came to spend their money locally. Depending upon the needs and wants of the individual families, it is quite possible that some of them spent more time in their motel than they did visiting local attractions.

Now I'm going to tell you a secret, if you'll promise not to share it with the millions of others who will be reading this book. Are you ready? Here it is. Despite the fact that my family often visited the Smokies as tourists, only once during any of our vacations did we actually stay in a Gatlinburg motel. (I will wait while you gasp and clutch your chest.) That one instance was in 1974, when we stayed at the Holiday Inn on Airport Road (where there is no airport). Otherwise, we primarily got out of the traffic congestion and stayed in Pigeon Forge. That's my confession, and now I'll go hide my face in shame while the rest of you enjoy this book. It's almost as much fun as being there!

Tim Hollis
August 2023

Introduction

Welcome to *Lost Motels of Gatlinburg*! Within these pages, you'll find a fascinating history of Gatlinburg's motels, hotels, lodges, inns, cabins and motor courts. Let's check in and explore!

While this is technically a book about motels, we'll be covering a wide range of lodgings that have come and gone throughout the years. With so many types of accommodations to cover, we have our work cut out for us. But why focus on the motel industry? That's a question I'm often asked, and it's not an easy one to answer.

Perhaps it's the sheer number of hospitality hot spots that have come and gone over the years that piques our interest. With the opening of the national park and the boom in Gatlinburg's tourism industry, the need for accommodations was on the rise. Many families who had lived in the Smokies for generations had to leave when the park was established, often with very little to their name. However, some of these families were able to use the money they received from the government for their land to purchase property in Gatlinburg and prosper from the tourism boom. However, the question remains: why have so many of these places vanished?

While survival in a tourist town is never guaranteed, it's clear that Gatlinburg's history and character are shaped by the resilience of its residents. Although we could spend volumes exploring each location's history, we'd barely scratch the surface.

I've always had a fascination with Gatlinburg's history in hospitality, and I'm sure many of you feel the same way. But the real reason I created this volume is simple: I love this area! Fifteen years ago, my wife and I made

INTRODUCTION

the move to Sevier County, and since then, we've begun our family. Knowing that our daughter will grow up in such a wonderful place fills us with immense happiness.

Speaking of wonderful places, what we've created here is a collection and database of Gatlinburg's bygone lodgings. However, there are a couple of things we need to take into consideration before getting started. Unfortunately, some locations couldn't be included in the book due to space limitations and limited information. Additionally, while some properties featured within the volume still operate as accommodations, their inclusion is based solely on their original structures and names.

Without further ado, let's dive into the heart of this collection, where you'll find postcards, brochures and 35mm photos that'll take you back to those family vacations and memories we all cherish. So, if you're ready to take a trip down memory lane, pack your bags and let's hit the road!

CHAPTER 1
The Parkway

If you've ever visited Gatlinburg, Tennessee, you've undoubtedly driven on US Route 441, which leads through Sevierville, Pigeon Forge and Gatlinburg before leading directly into the Great Smoky Mountains National Park. While there are many areas worth exploring around and outside of the area, the Parkway (Highway 441) is truly the heart of the town, containing most of the sights and sounds that make up downtown Gatlinburg. It's the perfect starting point to explore these beloved landmarks and to begin our book.

When you arrive in Gatlinburg via the "Spur," which is what the locals call the curvy mountain road that connects Pigeon Forge and Gatlinburg, you're immediately greeted with a plethora of attractions. Mini-golf courses, motels, museums, candy stores and gift shops all vie for your attention. My father first took me to this area in my late teens, and although I was a bit late to the game, I quickly fell in love with the place. He knew that it wouldn't be long before I left the nest and the opportunity to orchestrate these sorts of vacations would become increasingly more difficult. I can still remember entering the town for the first time and seeing all the wonderful landmarks, but it wasn't until I started visiting with my girlfriend, now my wife, that I truly discovered the beauty of this area.

Whenever we visited Gatlinburg, we made it a point to stay at the Midtown Lodge. As we drove up the Parkway, we felt a sense of familiarity wash over us. The Skylift ascended up the side of the mountain, the storefronts of both Aunt Mahalia's Candies and the Old Smoky Candy Kitchen came into

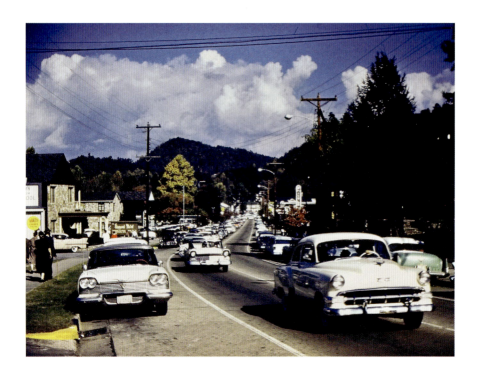

view and we could see the Ober Gatlinburg tram drifting into the clouds as it climbed Mt. Harrison. It was the late '90s, and the Parkway was still loaded with historic locations that spoke to Gatlinburg's tourism industry and its rich history. The Riverside Hotel, McKay's and the Midtown Lodge, among others, still stood tall, bearing witness to the stories of the past. Their legacies live on in our memories and in the tourism advertising that inspired this book. So let's dive in and get started!

BEARSKIN MOTEL

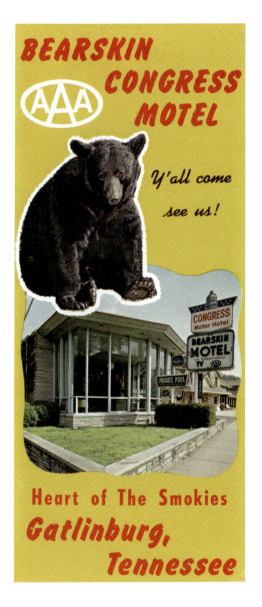

In the early 1940s, Hattie Ogle McGiffin established the Bearskin Tourist Home, which was composed of seven cottages constructed on family-owned land. This wasn't her first time running a prosperous business, as she had been employed starting at age fourteen at her father's general store and started her own establishment, the Bearskin Craft Shop, in 1932. As her business expanded, she added fifteen rooms and changed its name to the Bearskin Motel. The motel was demolished in the late 1980s to make space for the Bearskin Parking Garage. McGiffin's family continued the tradition of hospitality with the Bearskin Lodge, which opened in 2000 along the banks of the Little Pigeon River.

BOHANAN'S CABINS

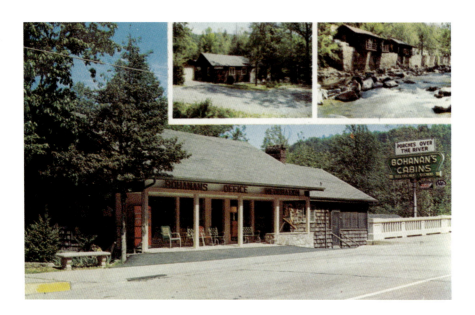

Ray Bohanan, owner of Bohanan's Craft Shop and Cabins, was a tenacious proprietor who beckoned passersby to his cabins by standing in the middle of the road and shouting, "Cabins! Cabins! Cabins for rent!" Ray, along with his brother Oscar and Lillard Maples, built and operated the Indian Gap Hotel before the national park was established. But when the government relocated the family, they saw new horizons and established Bohanan's Craft Shop and Cabins. Ray and his wife, Dessa Padgett, operated their shop and office on the Parkway, directly across from the Gatlinburg Mountain Coaster of today. Although no crafts have been sold there in years, the cabins on Hemlock Street continue to thrive thanks to rental agency Cabins for You. Ray's vision lives on through these rustic retreats, ensuring that his legacy endures.

CENTER MOTEL

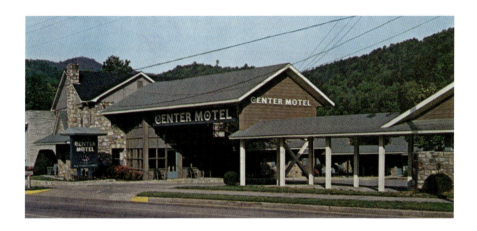

Orville Von and Estel Beryl Reagan, the siblings who owned Von Reagan's Cottages and Tourist Home, reworked their property and changed the name to Center Motel due to Gatlinburg's fickle tourism industry. The motel blended with the landscape perfectly, following the concept of using regional materials, such as earthy tones, stone hearths and knotty pine rooms. In 1960, the brothers sold their motel to Gatlinburg matriarch Hattie Ogle, and it has remained in the Ogle family ever since. Today, where the motel once stood, there is a TGI Fridays.

CONNER'S WATERLURE MOTEL

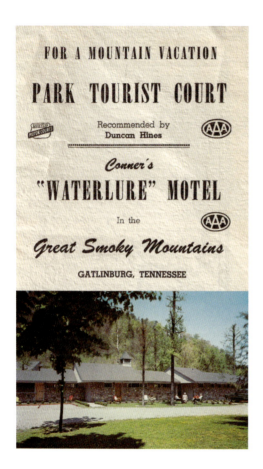

Claude Conner, the original owner of the Park Tourist Court, constructed a steel footbridge that connected his property to the island located directly behind it. Here, he built the ultramodern Waterlure Motel, consisting of eleven units, as well as a home for himself and his wife. The island was later purchased by Luther Ogle, who constructed the Twin Islands Motel and acquired the Waterlure in the process. The motel remained a part of the Twin Islands footprint until 2016, when it was demolished to make way for the Margaritaville Resort. Fortunately, Conner went on to develop Conner's Motor Lodge, which became a staple in Gatlinburg's history of hospitality.

COOPER COURT(S)

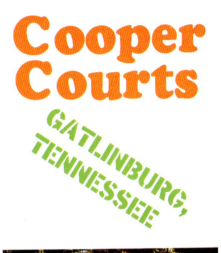

Fred and Blanche Cooper were a formidable duo with a wealth of motel know-how when they decided to enter the tourism industry. Blanche, being the daughter of one of Gatlinburg's founding families and having previous experience handling general management duties at the Riverside Hotel, gave them a significant advantage. After World War II, the couple began construction on their courts' distinctive zigzag floor plan, and by 1954, they were maintaining year-round operations. Visitors can still see the zigzag patterns and stone-faced columns at the Reagan Terrace Mall, which is a testament to the Coopers' legacy in Gatlinburg's early days of tourism and hospitality.

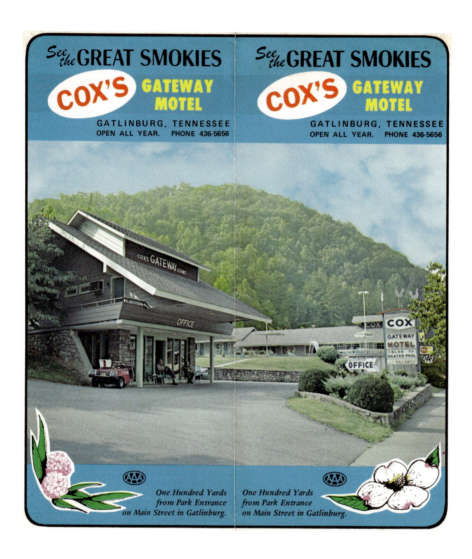

COX'S GATEWAY MOTEL

"I remember my grandad welcoming all the travelers; many families would visit every year," said Keith Cox. W.G. and Stella Cox operated their business with a true mom-and-pop spirit, treating each guest like family and never cutting corners. The initial layout of Cox's Gateway Motel consisted of log cabin settlements relocated from the national park, which developed into a fifty-room spread over the next five decades. In 1994, the Gateway Motel rented its last room, making way for the Clarion Inn that opened in April 1996.

EDGEPARK MOTEL

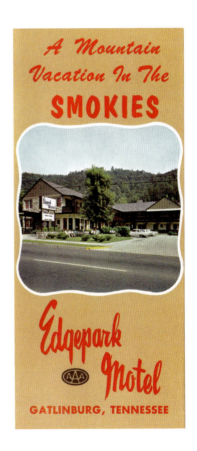

In the early 1940s, Ray Whaley founded the Edgepark Inn, the seventh motel built in Gatlinburg. His son, Ed Whaley, inherited the Edgepark at the age of fifteen, with his Aunt Nancy managing it until he was ready to take over. In 1980, Ed sold the property and retired but remained active in the hospitality industry, eventually building the Homestead House in 1982. Subsequently, the motel underwent expansion through a merger with the Whaley Motel, becoming the Edgepark-Whaley Motel. Unfortunately, the Edgepark Motel, with its rich history, closed and transformed into retail space. Tragically, in October 2022, a fire destroyed the location.

FOUR SEASONS MOTOR LODGE

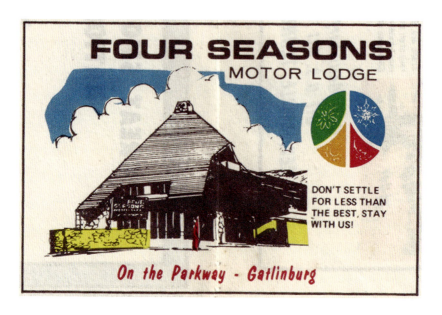

Brownlee Reagan, a self-made businessman born and raised in Gatlinburg, owned and operated the Four Seasons Motor Lodge, a well-known lodging establishment in the area. In addition to the Four Seasons, Brownlee also owned the Smokyland Motel, Belle-Aire Motel and Reagan Resorts Inn. The structures used for Reagan's Ramada Inn (previously owned by Barbara Parton Reagan) were purchased by Brownlee and redeveloped into the Ramada Inn Four Seasons, which included a convention center. The convention center hosted many events over the years, including Archie Campbell's nightly Hee Haw Show. The Reagan family parted ways with the Ramada franchise in the early 2000s, and the property closed permanently once the land lease expired circa 2015. The land is now home to the Sweet! Candy Shop, Fab Tees & Souvenirs and the State Highway 71 Parking Lot.

FRENCH VILLAGE HOTEL

During the 1940s, Porter Loomis and his family owned and operated several cottages and the French Tavern Restaurant. In the early 1950s, they expanded their business by constructing a three-story hotel in the courtyard previously used by village patrons. The French Tavern Restaurant was a popular dining spot, and Jeanette M. Loomis, inspired by its success, published a book titled *French Tavern Favorites*. The book contained sixty-four of her most popular recipes that were enjoyed by many visitors to the restaurant. Unfortunately, the hotel, cottages and restaurant no longer exist and have been replaced by the Elks Plaza.

FROST LODGE

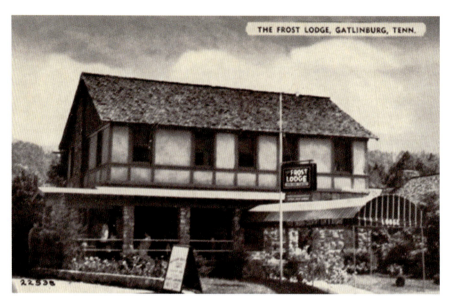

Norman Porter Collection.

The good old days, when rooms were less than five dollars a night! Such was the case with owner-operator Ina W. Frost and her aptly titled Frost Lodge (previously Woods Lodge). This two-story structure stood adjacent to Edna Lynn Simms' Mountaineer Museum (1931–55), one of the area's first attractions to celebrate Smoky Mountain culture and heritage. Today, the Hollywood Star Cars Museum and Gatlinburg Convention Center occupy the former site of Frost Lodge.

HEMLOCK MOTEL

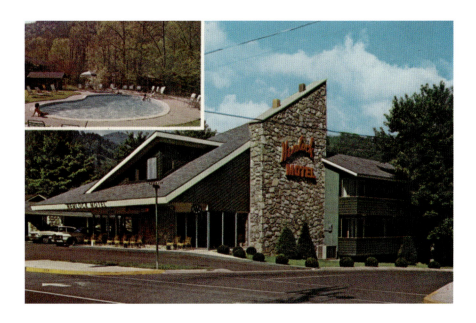

Charles Cate and his wife, Dorothy, opened the Hemlock Motel in Gatlinburg, Tennessee, after Charles's service in World War II. The motel was a true family enterprise, with the Cates family living on-site and the children making friends with returning guests. The Hemlock Motel was located on property gifted to Dorothy by her father, E.E. Maples (Maples Motel Cottages). The Hemlock Motel closed in the early 1970s when the land was leased to family friend Claude Anders to build his Tramway. In fact, portions of the Hemlock Motel were utilized in the construction of the Tramway's offices and retail shops. The Anders Family later purchased the Gatlinburg Ski Resort in 1975 and combined forces with the Gatlinburg Aerial Tramway. The dual properties were renamed Ober Gatlinburg in 1977.

HIGHLAND MOTEL

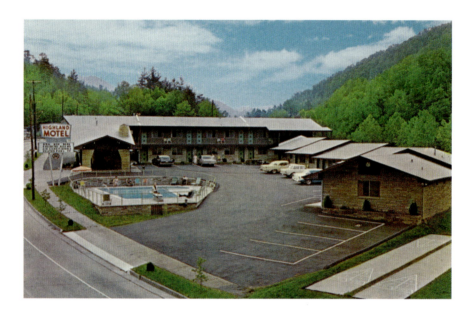

The Highland Motel was one of the first sights to greet visitors as they entered the northern city limits of Gatlinburg. Its modern design and friendly amenities, such as individual air-conditioning, wall-to-wall carpeting, dressing rooms, a heated pool, free coffee and even shuffleboard, made it a popular choice for tourists. The motel was aptly called the "Motel of Friendliness," and it was no wonder that many visitors chose to stay there. However, in the late 2010s, the Highland Motel (by then a Knight's Inn) was demolished, along with several other local businesses that marked the entryway to the city. As of this writing, the land where the Highland once stood remains vacant.

HILLCREST COURT

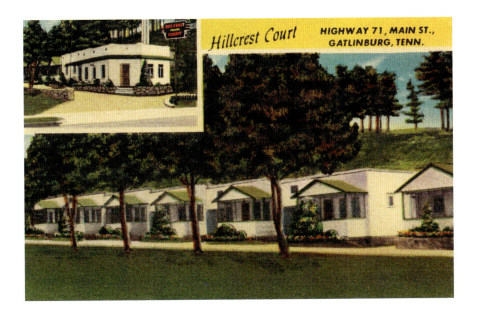

During the early days of Gatlinburg's tourism industry, a surge of hotels, motels and motor courts sprang up to meet the growing demand for visitor accommodations. One of the first to open was the Marilyn Cabins, which later became the Hillcrest Court Motel. Built by Orlie Trentham, the location opened its doors on July 4, 1938. However, today, other than a small cobblestone wall to the left of where the court once stood (now the Reagan Resorts Inn), there is little indication that this place ever existed.

HOLLY RIDGE COURT

Jim and Mary Evelyn "Bo" Trotter, owners of Holly Ridge Court, were pioneers in the area's growth. Jim began his hotel career as the manager of the Riverside Hotel in 1951, hosted the National Governors' Conference the following year and was named Man of the Year in 1963 by two hotel-motel industry trade journals. Mary Evelyn, a member of the Whaley family, a prominent Gatlinburg hotel family responsible for both the Riverside and Greystone Hotels, was also instrumental in the couple's success. Holly Ridge Court, a set of cobblestone cottages on a hillside in the center of Gatlinburg, was one of the couple's more unique ventures. Although partially surviving after all these years, the existing cottages are now part of Gatlin's Mini Golf, which features an eighteen-hole course that meanders through the structures. Unfortunately, one of the remaining cottages fell victim to the fires of 2016.

This spot at Gatlin's Mini Golf is actually one of the few remaining structures from the original Holly Ridge Court.

HOTEL GREYSTONE

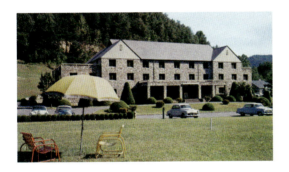

When Dick Whaley opened the Hotel Greystone in 1941 with his wife, Martha Cole Whaley, they had no idea that they would be leaving a lasting impression on Gatlinburg history. Dick obtained the land for the Greystone by trading his share of ownership in his parents' location, the Riverside Hotel. The experience he and Martha had gained over the years, with Martha also working in the industry for the Huffs and their legendary Mountain View Hotel, helped create a long-lasting legacy that continues to this day with the Miller family. The Greystone Lodge, which was completed in 1962, has carried on the historic name and is still going strong six decades later. The Hotel Greystone, which was the fourth of its kind established in the area, following the Mountain View Hotel (1916), Riverside Hotel (1925) and Gatlinburg Inn (1939), closed in 1998 and was replaced by the Ripley's Aquarium.

HUFF'S TOURIST COURT

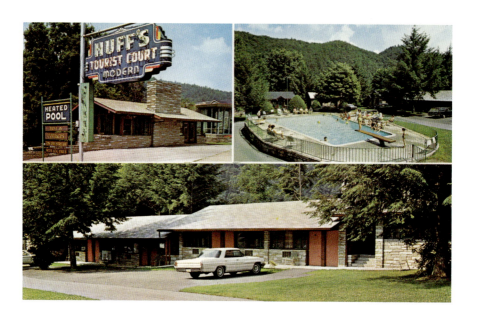

The Huff name is synonymous with Gatlinburg history, particularly its tourism industry. It all started in 1916 when Andy Huff built his two-story, ten-room Mountain View Hotel to provide lodging for traveling lumbermen. His sons Jack and Jim carried on the Huff legacy, with Jack establishing the Mt. LeConte Lodge (built in 1926) and Jack Huff's Motor Court (built in 1959). Jim's contribution to the family business was Huff's Tourist Court, which offered spacious grounds and utilized LeConte Creek to create a serene vacationing experience away from the hustle and bustle of the Parkway. Huff's Tourist Court served travelers until the late 1980s when it was removed to make way for the Hampton Inn that currently stands in its place.

Old Tyme Portraits still operates out of Huff's original lobby, the only remaining structure of the location.

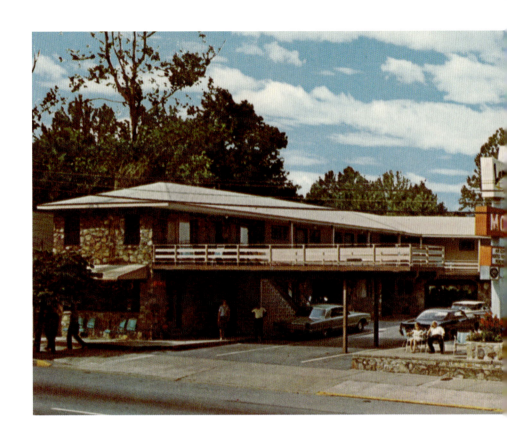

LANGDON'S PARK MOTEL

Langdon's Park Motel began as the Park Tourist Court/Service Station in the late 1930s to early 1940s when owners Mr. and Mrs. Claude Conner entered the growing hospitality industry. Their hard work paid off, and they expanded their footprint, leading to future endeavors such as Conner's Waterlure Motel and the Conner Motor Lodge, both owned by the Conners. In the early 1960s, A.B. Langdon purchased the property from the couple and changed the name to Park Motel and, later, to Langdon's Park Motel. After decades of business, the motel was removed to make way for—you guessed it—another parking lot, located crosswise from Atrium Pancakes' current location.

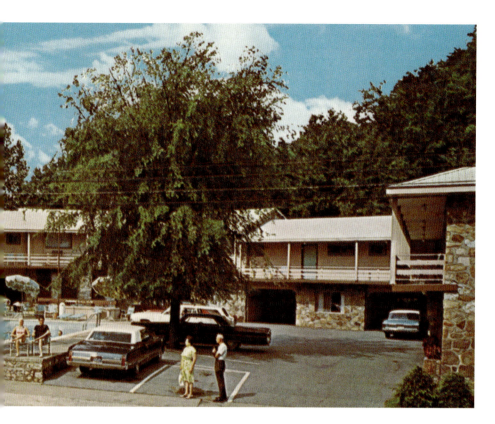

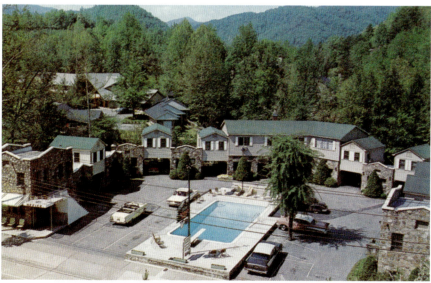

Before A.B. Langdon expanded the property and changed the name, this location was known as Park Tourist Court. It's also interesting to note the other bygone properties, like the Twin Islands Motel and Conner's Waterlure Motel in the top left of the picture.

LAY'S COURT

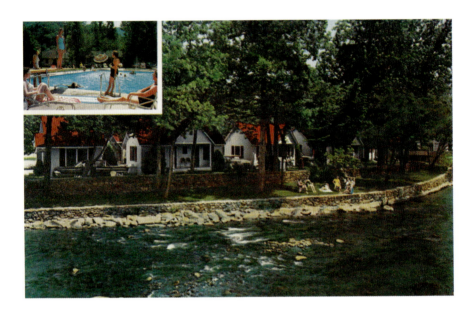

Lay's Court started with a few cottages and had grown to twenty-one by the early 1950s. Lloyd Cline, the owner at the time, added five more cottages and renamed it Town Court in the mid-'50s. The court then transformed into a mid-century modern design as the Four Seasons–South Court before becoming the Howard Johnson's Motor Lodge and Restaurant in the '60s. Today, portions of the Greystone Lodge on the River and No Way José's Mexican Cantina occupy the site where the court once stood, using the original structures built for the Howard Johnson's.

LOST MOTELS OF GATLINBURG

LECONTE CREEK COTTAGES AND MOTEL

According to the LeConte Cottages and Motel's brochure, "This is truly a garden spot," and Lewis Reagan's grandson Mark claims that this was truth in advertising. "He knew everything about trees, their roots, growing flowers…you name it!" Lewis and Ina Reagan started small, renting just a few of their native stone–constructed cottages to tourists. Throughout the 1940s and 1950s, the couple worked their way up to twenty-four units. In the 1960s, they expanded their location by adding a new motel to their wooden wonderland. Later on, the Reagans sold the property to retire, but not before Lewis served as mayor of Gatlinburg for ten years. Today, very little is noticeable of the original property, which is now the Quality Inn Creekside. However, the original rock-walled banks running along the LeConte Creek still exist.

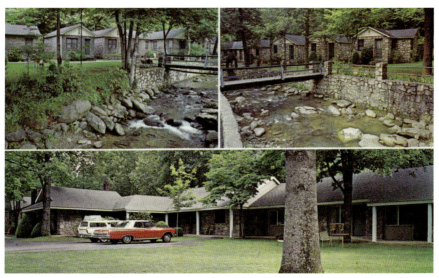

This photo perfectly captures the evolution of the LeConte Cottages, which by then had expanded to include a full-fledged motel.

MAPLES MOTEL COTTAGES

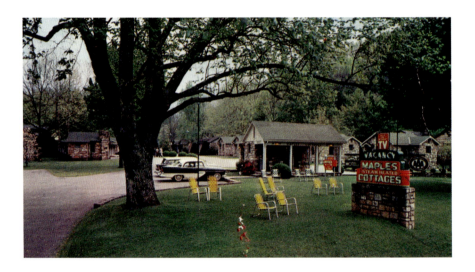

Maples Motel Cottages was an obvious choice in Gatlinburg's daily hustle and bustle. Its spacious lawns provided ample distance from the highway noise, and that alone assuredly kept the "NO VACANCY" sign a-burning. The quaint little cottages were owned by E.E. Maples and were once located on the northern end of town, approximately where the Calhoun's and Cherokee Grill sit today.

MCKAY'S MOTEL

Mr. and Mrs. John McKay were responsible for making McKay's Motor Lodge a Gatlinburg landmark for over sixty years. John, a mason by trade, built several stone cabins when they first began their business, which they named the Parkway Tourist Court. In addition to this, he also built the Parkway Restaurant where the Bubba Gump Shrimp Co. is now located. Beyond the motel, the McKays also owned a gas station located on Airport Road. The family further expanded the motel's amenities by introducing McKay's Restaurant, which operated until the late '80s and was later leased

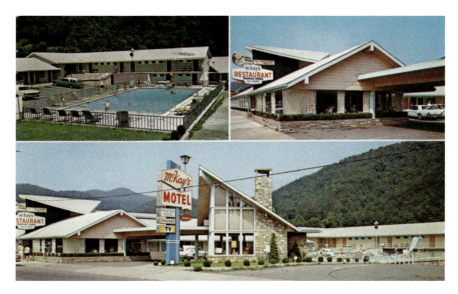

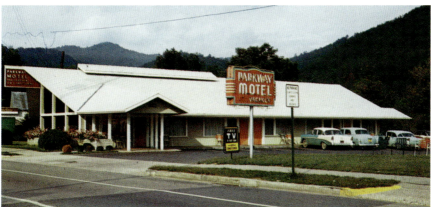

to the Linebergers Seafood Company. The location underwent several changes throughout its history, including the conversion of the original stone cabins into a motel. The family also changed the name of the motel multiple times, beginning with Parkway Motel. It was later renamed McKay's Motel, then McKay's Motor Lodge, McKay's Motor Lodge Downtown and finally McKay's Inn Downtown. After the former inn closed in January 2005, the site was redeveloped to include a Dick's Last Resort Restaurant, the Old Smoky Moonshine Distillery and other businesses.

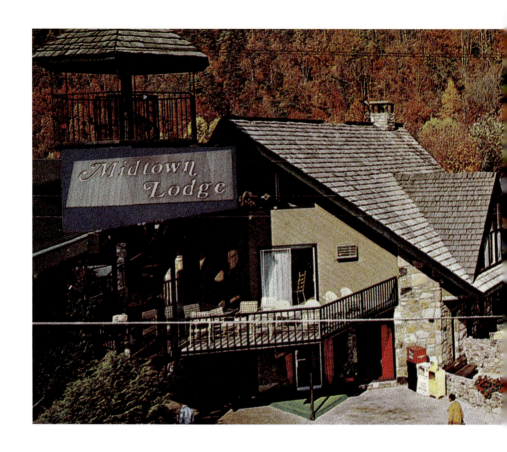

MIDTOWN LODGE/ WHITE OAK FLATS MOTEL

In the late 1930s, Sydney Lillard Maples and Edna Bohannon Maples embarked on the construction of what they initially called the White Oak Flats Guest House and Tourist Cottages. The first structure, featuring four rooms and four baths, was crafted from wooden barrels. However, in 1941, during the first of many renovations, they added concrete blocks between the barrels, resulting in the creation of five individual units. By 1952, an expansion project introduced nine rooms in one continuous unit, complete with a lobby and a restaurant on the upper floor, which was completed in July 1953. During the '60s, the property expanded from 20 to 90 units, while operating under the Travelodge brand name, one of the first motel chains in the United States. However, following the passing of Lillard and Edna in the early 1970s, their children decided to part ways with the Travelodge brand, renaming the

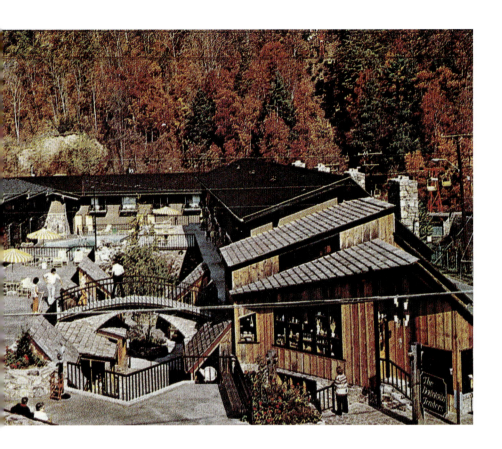

establishment the Midtown Lodge. Over the years, the property continued to expand, eventually reaching a total of 135 units. In addition to the room count, the property also added a collection of shops known as the Downtown Traders Mall. Unfortunately, in 2012, the historic Midtown Lodge was demolished to make way for the Sugarlands Moonshine Distillery and a parking deck.

The owners of the Midtown Lodge, formerly known as White Oak Flats Motel, decided to switch up its name to not only reflect its location but also, most likely, to resonate with tourists unfamiliar with Gatlinburg's previous name.

MOUNTAIN VIEW HOTEL

In 1916, Andy Huff erected the Mountain View Hotel in Gatlinburg, Tennessee, to accommodate lumbermen purchasing timber. The hotel had ten units, two stories and one bathroom on each floor. Over the years, it underwent renovations and expansions, including a 1924 addition of a new dining room wing and guest rooms. In 1929, a larger hotel with a grand lobby and impressive fireplace replaced the original building. The Mountain View Hotel was honored to host many notable guests, including the esteemed Eleanor Roosevelt, who stayed in a suite of rooms furnished with new furniture by Andy Huff, in the late 1930s. Despite his hectic schedule, Huff was a dedicated advocate for creating the Great Smoky Mountains National Park. Regrettably, the Mountain View Hotel was demolished in 1993, despite its listing in the National Register of Historic Places.

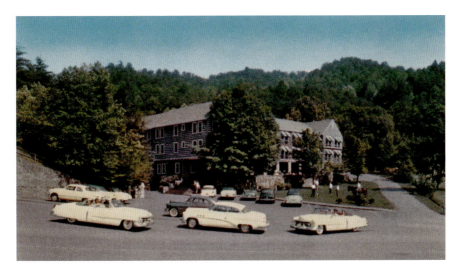

In the earlier years of tourism in Gatlinburg, several locations offered touring cars, just like the ones captured in this 1953 photo of the Mountain View Hotel.

PARKWAY MOTOR INN

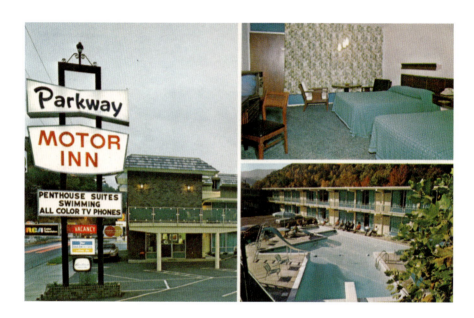

For decades, the Parkway Motor Inn, under one name or another (Friendship Inn, Stony Brook Motel), vied for the business of weary-eyed tourists as they entered Gatlinburg at the lower end of town. Its forty new, spacious and extra clean rooms were highly sought after, and the motel was a popular lodging establishment. However, like several other local businesses, including the Knights Inn (formerly the Highland Motel) and Cooter's, the Parkway Motor Inn (Stony Brook Motel at the time) was demolished in the late 2010s. Today, the Appy Lodge sits across the street from the former site of the Parkway Motor Inn, which was situated on Highway 321/US 441 South (Parkway).

PLEASURE ISLAND

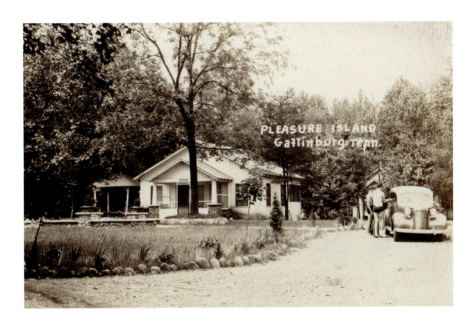

In 1948, Amos Fox purchased Pleasure Island from the Pierce King family during an estate sale, with the financial help of his previous employer. The location was not actually a motel but rather a collection of twenty-one cottages encircled by a gravel road, with each unit overlooking Cliff Branch, an extension of the Little Pigeon River. "Two or three of the cottages were alike, but the others were all different. There was even a circular-shaped unit, with a round living room that we referred to as the 'roundhouse,'" recalled Fox's daughter Frances. Amos sold the lower end of the property, which later became Conner's Waterlure Motel, to help fund the construction of a new bridge, an office building and two additional cabins. Sadly, a devastating flood in the early '50s destroyed many of the older cabins, along with all the newly constructed additions on the front half of the island. Fox sold the island soon after the flood, making way for the Twin Islands Motel, and began construction on what would become the Fox Motel on Route 73.

RAWLINGS MOTEL

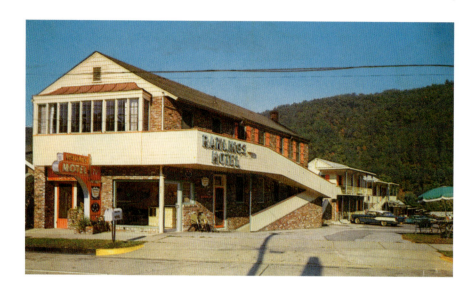

Owner Rush Rawlings entered the hospitality business firstly with cottages and a dry-cleaning service, but eventually converted the entire property, including his home, to a more contemporary motel composed of twenty-two units. Rawlings's son Jerry recalls, "My mom and dad ran the place, just like every other motel owner in town did, and did so until they retired in the late '60s." It was during this transition that the land was leased to businessmen who determined that starting from scratch would allow them to create something more modern; thus the Royal Townhouse Motor Inn was established.

REAGAN'S MOTEL

Barbara Parton Reagan, also known as "Mom Reagan," developed Reagan's Tourist Court at the corner of Reagan Drive and Parkway into a family business. By the early 1960s, the tourist court had expanded to thirty-five rooms, including a motel, a private heated swimming pool and the S &

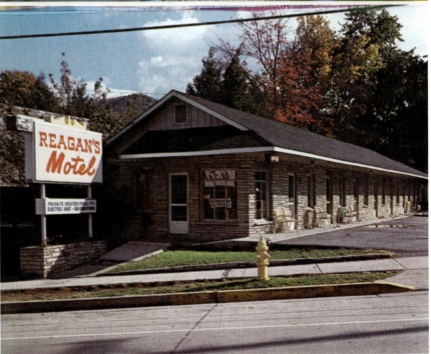

M Restaurant, owned and operated by Barbara's son Stuart and his wife, Myrtle. However, the property faced challenges, including the completion of the 407-foot-tall Gatlinburg Space Needle in 1969, which caused an ongoing issue with people dropping coins onto the motel roof. During its second ownership, the land was leased and the motel structures were sold as Reagan's Ramada Inn to Brownlee Reagan, a local businessman and influential member of the Gatlinburg community. The location has since been demolished and replaced with a variety of businesses, including Crawdaddy's Restaurant and Oyster Bar, Auntie Anne's Pretzel Store and a parking lot.

RIVERMONT MOTOR INN

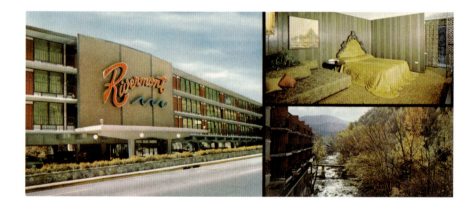

Gene Vaughn, a U.S. Army veteran and local businessman, built and managed the Rivermont Motor Inn in 1972. He continued to oversee the property until selling it in 1988. Although Vaughn passed away in 2011, his vision of beautifully decorated rooms with views of the Great Smoky Mountains still exists. The inn, now operating as a Baymont by Wyndham, maintains its original location along the riverside. Unfortunately, the iconic Rivermont signage is no longer visible, but the inn's legacy lives on.

RIVERSIDE HOTEL

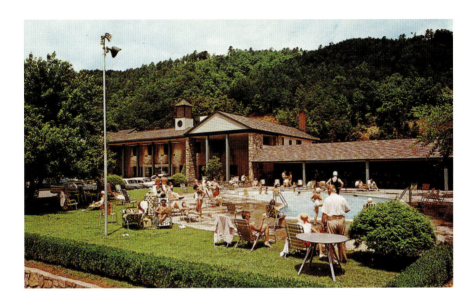

In 1925, Stephen "Uncle Steve" Whaley built the first Riverside Hotel in Gatlinburg, which started as a boardinghouse that faced the river and charged thirty-five dollars per month for lodging and meals. The hotel stood alongside the only other hotel in Gatlinburg at the time, the Mountain View Hotel, and was built on twenty-five acres of land that Stephen and his wife, Pearlie Trentham Whaley, had purchased from Richard R. Ogle in 1917. In 1932, Stephen's son, Austin E. "Dick" Whaley, joined him in managing the Riverside Hotel, which they later renovated and rebranded in 1937 to face the new road (Highway 441), creating the New Riverside Hotel. After managing the hotel for nine years, Dick sold his interest to his father and built the Hotel Greystone in 1941. The Riverside was then run by Bruce, Stephen and Pearlie's son, and his brother-in-law James Trotter for two decades until they sold it after building the River Terrace Motel. The hotel underwent a renovation in 1953 with a front featuring stone columns designed by Gatlinburg architect Hubert Bebb. The hotel closed in 2013 after more than eighty-five years in operation.

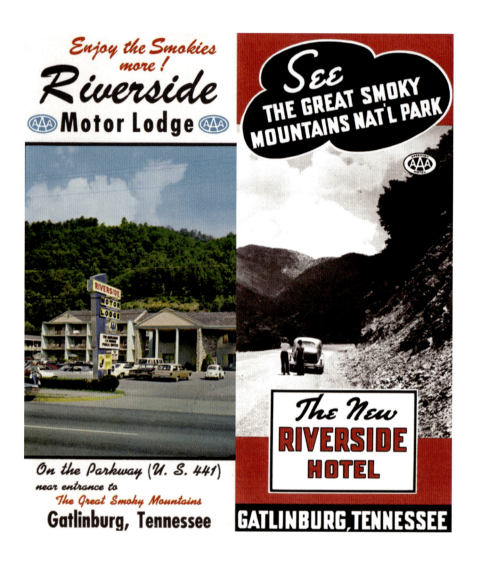

It's interesting to see how the Riverside Hotel, like other enduring establishments, adapted to the changing times by altering its name. This vintage advertisement showcases the Riverside Motor Lodge from the '60s and the New Riverside Hotel from the late '30s.

ROBBINS TOURIST COURT

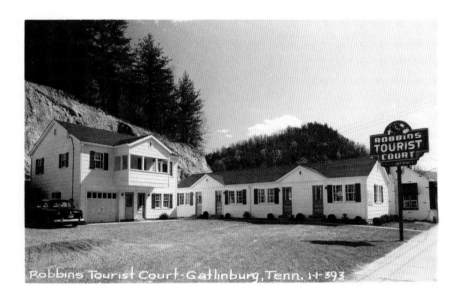

Nestled among a seemingly endless stretch of motels and souvenir shops, the Robbins Tourist Court was a fine example of Gatlinburg hospitality, providing grade A service with a smile. Owner-operator J. Albert "Pop" Robbins welcomed guests with the phrase, "It would tickle us sight good to have you come back agin' an [*sic*] stay a spell." The tourist court was located on the Parkway where the Flapjack's Pancake Cabin now sits.

ROYAL TOWNHOUSE MOTOR INN

The Royal Townhouse Motor Inn was an elegant Mediterranean-style destination fit for a king. Its natural stone, wood-burning fireplaces and rooftop heated swimming pool overlooking the city set it apart from other motels. Constructed in the early '70s, the Royal Townhouse replaced the Rawlings Motel, which had successfully occupied the land for many years prior. Located next to the LeConte View Motor Lodge, the Royal

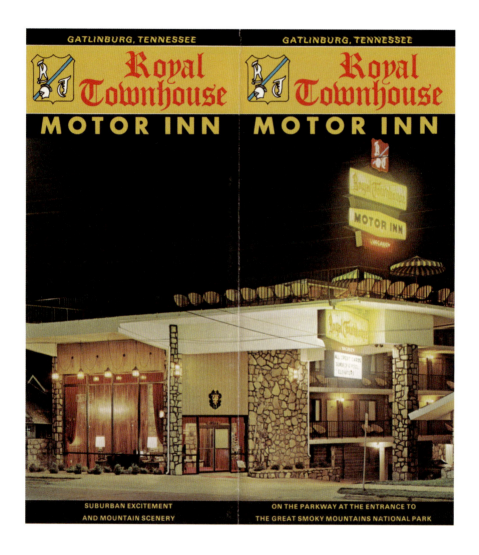

Townhouse became a part of Gatlinburg's history. However, after more than four decades in the tourism trade, the Royal Townhouse closed its doors in June 2018. The property sat dormant until its demolition in 2022, and the land remains vacant as of this writing.

SMOKY HEIGHTS RESORT

Smoky Heights Resort, with its twenty-two cottages, was a popular spot from the 1920s to the 1950s. It was situated on the right side when entering Gatlinburg from Pigeon Forge. O.R. Medlin, a businessman, owned both the resort and the Terrace Motel across the street. The resort had a special location by the Little Pigeon River, connected to the Parkway by a charming stone bridge. Medlin wanted the town to offer modern amenities while preserving its old-time charm, and this property, with its stunning view of Mount LeConte, achieved that beautifully.

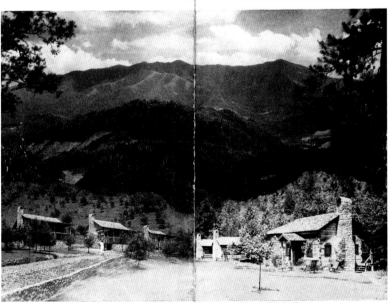

SMOKYLAND MOTEL

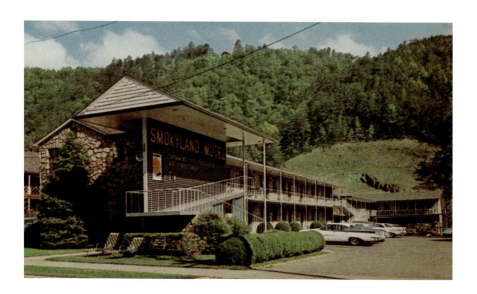

After a stint with the U.S. Road Survey Division during the late 1940s and leasing a Mobile Gas Station in 1950, Mayford Clabo and his wife, Beulah, obtained a loan to build the Smokyland Motel in 1952–53. The couple owned and operated the property until selling it in 1964 to Glenn Glass, a Tennessee Volunteers and Philadelphia Eagles football player. The Smokyland, sandwiched between the Edgepark Inn and the Riverside Hotel, eventually found its way into the hands of local businessman Brownlee Reagan, who kept the ship afloat for many years to come. Brownlee and his family were no strangers to the industry, as they owned and continue to own several properties throughout the area. The motel's architecture, which included sharp angles and peaks mimicking the mountains behind, provided a design in tune with the area's natural surroundings and contributed to its more than five decades of service, making it a touchstone in Gatlinburg's tourism industry.

TERRACE MOTEL

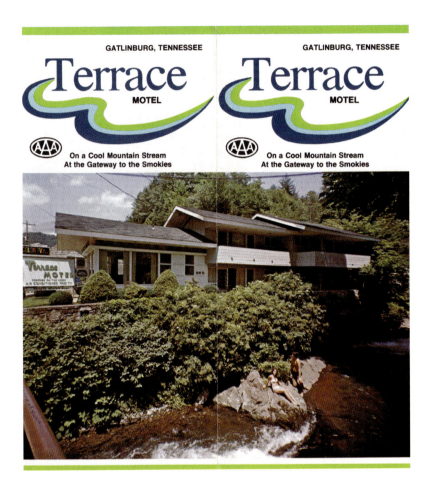

If you had the pleasure of lodging at the Terrace Motel, you would know that its claim of "water from the Roaring Fork Creek lulling you to sleep" was not merely an advertising ploy but a veracious statement. Earl and Margery Helms, who owned a dairy farm in Maryville, Tennessee, sought a simpler way to make a living and thus purchased the Terrace Motel from O.R. Medlin, the proprietor of Smoky Heights Resort. The Terrace provided guests with ultramodern motel units and private cottages, but its appeal went beyond modern amenities. Honeymooners, couples and families alike

were captivated by its early American motifs and rustic, natural mountain ambiance. When asked if Earl and Margery ever owned any other businesses, their daughter Susan recollected, "My parents never wanted anything more than they can handle, and they were happy with the way it was." The couple owned the property for an impressive forty-seven years. Regrettably, the cherished Terrace Motel met its demise in 2016 to make way for Ripley's Mountain Coaster, which now stands at 386 Parkway.

TRENT MOTEL

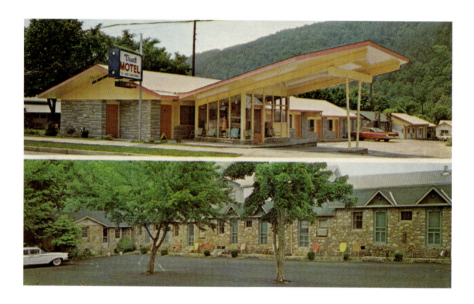

The Trent Motel's angled awning could wave down potential patrons from a mile away, and it did just that until it closed shop in the early 2000s. Owners Charles and Nell Marie Inman, along with Stella T. Cole, ran this modestly designed twenty-three-unit motel, choosing to keep it simple: location, location, location! The Trent was conveniently located just a block from the park entrance, the civic auditorium and numerous shops and restaurants, keeping heads on the pillows year after year. Needless to say, it was a hot spot. However, time marched on, and this prime real estate is now home to the Amazing Mirror Maze & Circus Golf.

TSALI LODGE, MOTEL AND CABINS

The Tsali Lodge, named after the noted Cherokee leader, was technically the last property you passed before entering the Smokies. Its picturesque ten-room spread actually adjoined the national park. After a name change in the late 1940s/early 1950s, the property was known as Grabel's Motel. Later, businessman Jack Miller Sr. built his Open Hearth Restaurant (est. 1953), which became a Gatlinburg tradition until the 2000s. Today, the Nantahala Outdoor Center occupies the former site of Tsali Lodge.

TWIN ISLANDS MOTEL

Luther "Coot" Ogle began his career in hospitality in 1934, when he started working at the Mountain View Hotel, Gatlinburg's first hotel established in 1916. There he learned the ins and outs of motel operation and the importance of saving every penny of his eight cents an hour work wage. In 1942, Coot and his sister and brother-in-law purchased their first business, the Beer Barn. Three years later, Coot bought A Sip and a Bite, a local eatery where the Landshark Bar and Grill now sits. This restaurant is worth noting because it was later changed to Ogle's Café and then again to Ogle's Buffet, Gatlinburg's first buffet-style restaurant. In 1950, Coot purchased Pleasure Island from Amos Fox after a major flood destroyed a large portion of its cabins and cottages. To avoid future flooding, Coot raised the island's elevation with walls built of native stone and began construction on his newly coined Twin Islands Motel, which initially consisted of 20 units. The motel was designed by architect Hubert Bebb and completed in 1951. Sadly, the motel was closed and demolished in 2016, making space for the tropic-inspired Margaritaville Resort to open its brightly colored doors in 2018. In the end, the Twin Islands Motel had expanded to a total of 112 rooms.

VON REAGAN'S COTTAGES AND TOURIST HOME

Siblings Orville Von and Estel Beryl Reagan constructed cottages on land purchased by their parents soon after relocating from the national park. The property changed names a few times over the years, from Von Reagan's Cottages and Tourist Home to E.B. Reagan's Motel and Cottages. The siblings eventually converted the property to a more contemporary motel setting, which they titled Center Motel. Von eventually entered the restaurant business, establishing Smokies Restaurant and the area's first waterslide, Water Boggan. Meanwhile, Estel continued in the hospitality industry, building the iconic Skyland Motel that overlooked the city on Route 73 for decades. Center Motel was sold to Hattie Ogle in 1960 and was later demolished and replaced with a parking deck and TGI Fridays Restaurant.

WHALEY MOTEL

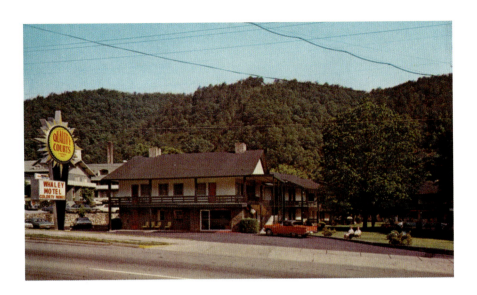

Following the success of the Hotel Greystone, owners Dick and Martha Whaley expanded their footprint on Gatlinburg's hospitality industry with the aptly titled Whaley Motel. The centrally located property, managed by the Whaleys' son Robert and his newly wedded wife, Koleen, boasted the same recreational facilities as its predecessor, including a large swimming pool and tennis and shuffleboard courts. The Whaleys' architectural design emphasized the region's natural environment, with soft, rustic color schemes enhancing the motel's aesthetic appeal. After the Whaleys sold and retired in the 1970s, the motel underwent some changes, including a merge with its neighbor, the Edgepark. Ultimately, the Whaley and the Edgepark both closed, making way for retail shops and restaurants, including a McDonald's at one point. Sadly, the original Whaley structures, along with several other businesses, were destroyed in a fire in October 2022.

WILLIAMS MOTEL

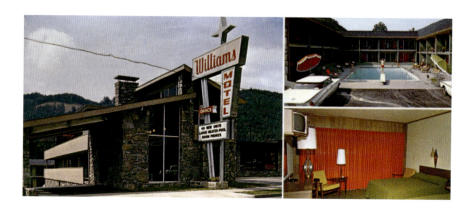

The Williams Motel was situated on the upper end of the Parkway, just a block before entering the national park. While the original building constructed by Mr. and Mrs. Freeman Williams still stands and operates today, structural changes over the years have made it nearly unrecognizable. It's worth noting that the former Williams Motel, particularly its lobby, once provided a gallery for nature artist Paul W. Brown's watercolor paintings of the Smokies. The motel now operates as a Days Inn.

CHAPTER 2
Airport Road

Airport Road has been a cornerstone of Gatlinburg's motel industry for years, serving as a home to many accommodations over the years, but the name of the road dates to the early twentieth century. According to local legend, a pilot who had run out of fuel was forced to use a field that is now the site of Airport Road as a landing strip. Unfortunately, the field was too short, and a large tree blocked the end of the "runway." For him to take off again, the pilot and the landowner had to remove the tree, and the name "Airport Road" was born. Today, at the end of Airport Road, visitors can find the entrance to the Roaring Fork Motor Nature Trail, a five-and-a-half-mile-long, one-way loop road that is filled with mountain streams, historic cabins and other buildings. Although the road's name was changed to Historic Nature Trail in September 2000 to better advertise the attraction, in January 2023, the town decided to revert to its original name, Airport Road, to honor its unique history.

Airport Road has undergone significant changes over the years. This chapter features entries on some of the wonderful family-owned motels that once lined the street, many of which have been completely removed or repurposed in a way that makes them virtually unrecognizable. While some original motels, like the Sydney James and the Gillette, have managed to keep their doors open since their establishment in the late 1950s, a testament to Gatlinburg's golden age of tourism, many others have closed down due to fierce competition from chain companies. It's important to keep the memory of these locations alive and explore the history they hold. One of the most

recognizable non-motel landmarks in Gatlinburg is the Space Needle, located right here on Airport Road. Let's take a ride to the top and gaze at the area below, then discuss the locations where some of these motels once stood and imagine the memories they hold.

ALTO MOTEL

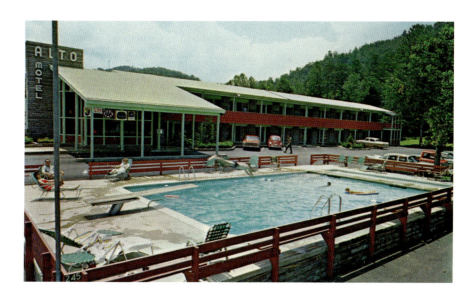

This modern beauty (built in 1965) came equipped with wall-to-wall carpets, heated pool and air-conditioning—everything the most discriminating tourist of the time required! Owner Elizabeth "Lib" Ogle Dunn lovingly named the property Alto, a combination of her children's names, Mary Alice and Tom. It's long since been replaced by one of the chain resorts of the time (Holiday Inn Club Vacations Smoky Mountain Resort at the time of this writing), but not all is lost. Vintage pieces of Airport Road can still be found if you look closely.

ARLEE COURT

Though it's becoming more unusual to see motor courts in this day and age, they were a dime a dozen during the first half of the twentieth century. Owners Arlena and Lee Cassady maintained the eighteen "noise-insulated" units of Arlee Court (clever name) on the upper end of Airport Road (Historic Nature Trail), next to the Glenstone Lodge. Motor courts like Arlee Court were popular back then, as they catered to the needs of travelers who could conveniently park their cars right by their rooms. It's hard to imagine the lush green grass that adorned this bygone beauty. Nowadays, most of the grass has been replaced with concrete, reflecting the town's transformation over time.

BEARLAND COURT

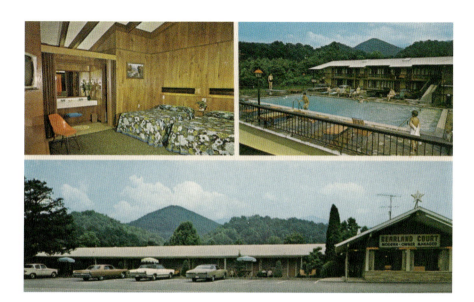

Bearland Court was initially a house, but owner Forest May saw the potential of the growing tourist industry, leading to its eventual expansion into a motel. The addition of the Bearland General Store helped the motel stand out by providing tourists with the conveniences of home and eliminating the need to venture into the Parkway's hustle and bustle. Although the lodging was removed more than a decade ago to make way for visitor parking, the general store continues to thrive and stake its claim in Gatlinburg's history.

BELLE AIRE MOTEL

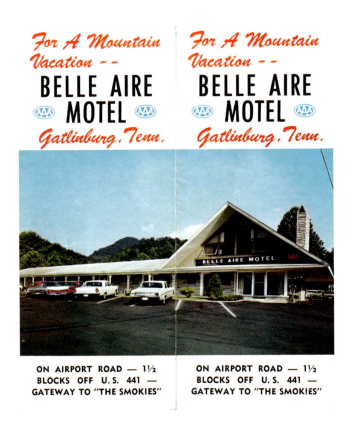

The Belle Aire Motel, which was named after a motel outside of Cherokee, North Carolina, has sat at the corner of Historic Nature Trail and Belle Aire Lane since 1958. Over the years, owners Brownlee and Kelley Reagan successfully turned the twenty-seven-room property into a family-friendly hot spot, not only attracting tourists but the local kids as well. "It was a place where all the local kids hung out. It would be crazy busy with the many kids who lived in the downtown area," recalls Brownlee and Kelley's son Lee. Even though the Gatlinburg of the 1950s is virtually unrecognizable, the Belle Aire endured, somehow managing to retain its mom-and-pop mid-century charm. Nevertheless, after sixty-five years of operation, the owners have decided to call it quits, scheduling the property for demolition in 2024.

BUCKEYE MOTEL

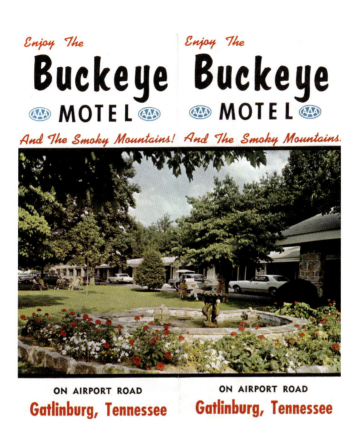

Jack and Evelyn Meyers, the original owners of the Buckeye Motel, knew how to delight their customers. They offered an array of rooms, some with ultra-modern interior design and others with a vintage flair, complete with antiques. Over the years, the property has undergone changes, but the magnificent mountain backdrop remains. Although now operating under the Super 8 brand, the motel still retains some of its original character, such as the lobby's arched entrance. The motel's spacious lawns have been replaced with pavement, but it still preserves a piece of Gatlinburg history.

CLOVERLEAF MOTEL

The Cloverleaf Motel, owned by Gordon Landreth and Alda Clapp, was situated next to the Log Cabin Pancake House. While this ranch-style getaway served the visitors of Gatlinburg for many years, its future was in a trio of properties that would ultimately become the Rocky Top Village Inn (more on that later). The street next to the Gillette, just a few doors down from where the Cloverleaf Motel was once located, is called Cloverleaf Lane. It's unclear whether the street name was inspired by the motel or if it's just a coincidence. Maybe someone really loved clover!

DOGWOOD MOTEL

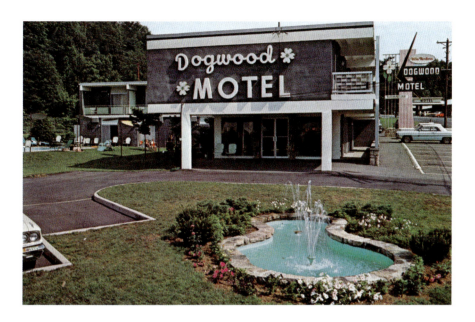

The Dogwood Motel, or what remains of it, can still be found at the corner of Airport Road (Historic Nature Trail) and McCarter Road. It's now home to the Gatlinburg Town Square by Exploria Resorts. Initially, it was pastel pink, but in the late '60s/early '70s, it switched to a gray color scheme, as shown in this image. Later on, the Dogwood Motel underwent another transformation, adopting a cream-and-brown color palette in the late '70s/early '80s that blended more along the lines of the natural environment and surrounding colors. In addition to the Dogwood Motel, across the street just a couple doors down, the aqua-blue-and-pink-adorned Smoky Mountain Plaza Motel joined in, adding a vibrant splash of color to Gatlinburg's typically earthy-toned establishments.

HOLIDAY INN

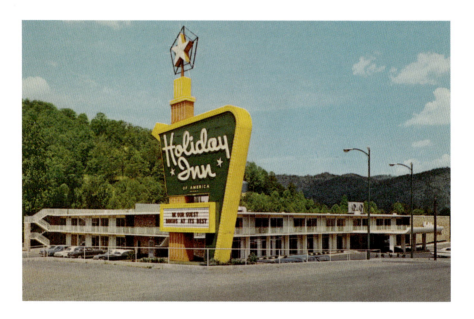

Holiday Inn, or the "host from coast to coast," as its tagline boasted, gave tourists a familiar face and caught their attention with unforgettable roadside signs. Founder Kemmons Wilson envisioned prominence with his fifty-foot-tall "Great Sign," and the Gatlinburg location was no exception. Although the vintage signs were phased out in the early '80s, Holiday Inn has continued as one of the largest hotel chains globally. Although the Gatlinburg location was demolished in the early 2000s (currently Hampton Inn), a new Holiday Inn Express is only a block away.

HOLIDAY MOTEL

The Holiday Motel, originally known as the Rendezvous Motel, was situated across the street from the present-day Gatlinburg Convention Center. The Rendezvous's sign was removed, and the property was extended closer to the road when it became the Holiday Motel. The motel's advertisements touted its location as the "first on Airport Road." While that may have been true in later years, the Mountain Air Motel, which later became the Mountaineer Motel, could have made that claim in its early days. Notwithstanding, the Holiday Motel's twenty-six units of style and symmetry were a popular destination for travelers. Regrettably, the site is now nothing more than a parking lot, fittingly named the Holiday Lot.

LEDWELL MOTEL

The Ledwell Motel underwent a revival when it merged with the Sidney James Motel, a well-known institution in Gatlinburg. This hideaway, owned by Roy and Lois Ledwell, was a peaceful retreat that offered easy access to nearby attractions. It was situated on the corner of Airport Road and Cherokee Orchard Road, right across from the Sidney James Motel. Although the motel's original color scheme has since been updated, its structure remains intact.

MORGAN MOTEL

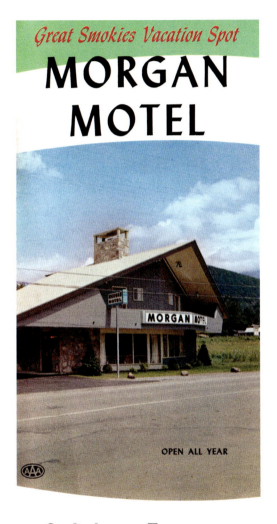

Robbie and Milton Moore were visionaries indeed. Their mid-century property had a sleek modern design that would attract any potential tenants. Built in 1961, the "fully carpeted-20 units" were located next to the Mountain Manor Motel (now Mountain Manor Parking) and across the street from the civic auditorium. Today, the property is the home of the Microtel Inn and Suites.

MOUNTAIN AIR MOTEL

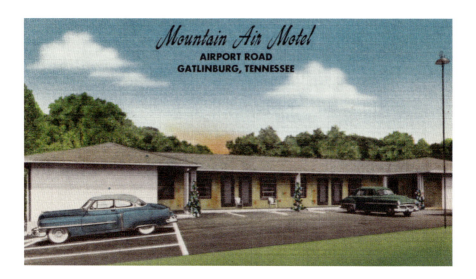

The Mountain Air Motel is a significant part of Airport Road's history, as it was the very first motel that visitors would have come across when turning onto the road. Owner Hall Sayles later expanded the property, adding a uniquely styled office building and increasing the number of rooms from twelve to eighteen. Additionally, he changed the name to Mountaineer Motel. Eventually, the motel was sold to new owners and relocated to Highway 73. Today, the iconic 407-foot-tall Space Needle stands in the motel's former location. The Mountaineer Motel operated on Highway 73 for many decades until it was tragically destroyed by wildfires in 2016.

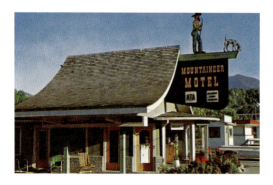

The addition of a mountaineer happily puffing on a corncob pipe perfectly embodied the idyllic mountain life that tourists often envisioned.

MOUNTAIN MANOR

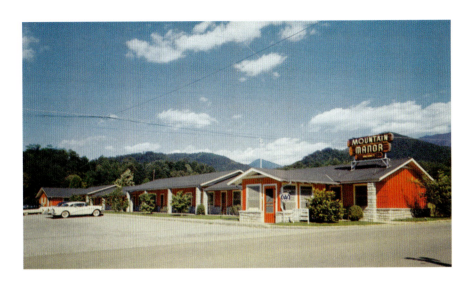

Mountain Manor, with its eighteen cozy rooms, provided a tranquil retreat, as proudly stated in its brochure. Buford Reagan, the owner, also operated Buford's Court on Roaring Fork Road. Regrettably, both locations have vanished. Once positioned next to the present-day Microtel Inn, Mountain Manor suffered the same fate as its neighboring Holiday Motel. Today, the site remains merely a parking lot, but the motel has been commemorated as Mountain Manor Parking.

ROCKY TOP VILLAGE INN

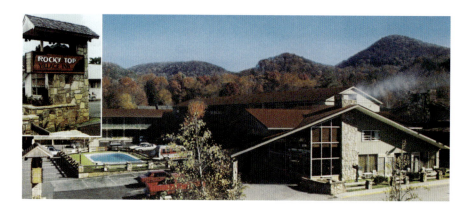

Felice and Boudleaux Bryant composed more than eight hundred songs during their legendary career, including "All I Have to Do Is Dream," "Bye Bye Love" and "Wake Up Little Susie." The Rocky Top Village Inn was a combination of two motels purchased by the couple after they moved to Gatlinburg, Tennessee, in 1978. The Cloverleaf Motel and the Colonial Motel constituted the initial phase of the property; Felice and Boudleaux purchased the Spain Motel in 1986, increasing the total number of their rooms to eighty-nine. The property's name comes from the landmark song "Rocky Top," which the couple composed in 1967 while staying at the Gatlinburg Inn (est. 1937). The space once occupied by the Rocky Top Village Inn is now home to the Courtyard Marriott, which opened after the inn closed in March 2014.

SMOKY MOUNTAIN PLAZA MOTEL

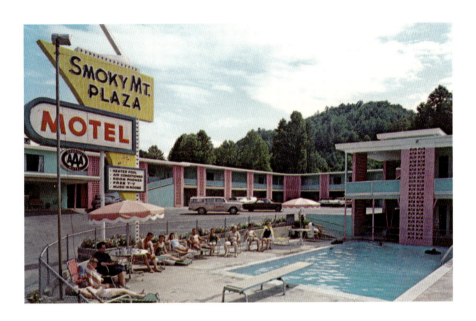

Lee and Verla Crosno knew a thing or two about plans not going as expected. As luck would have it, the motel they had planned to build on the sunny beaches of Florida found a home nestled at the foot of the Great Smoky Mountains National Park instead. On their way back from property hunting in Florida, they decided to detour in Gatlinburg and fell in love with the area. They opened their aqua blue and pink accommodations in 1952, and by the mid-'60s, the motel had expanded to more than double its original size, with forty-four units. The Smoky Mountain Plaza Motel's pastel palette, Verla's favorite colors, remained until the motel closed after Lee's death in 1974. Today, the Holiday Inn Express now occupies the very spot where the motel once stood.

SPAIN MOTEL

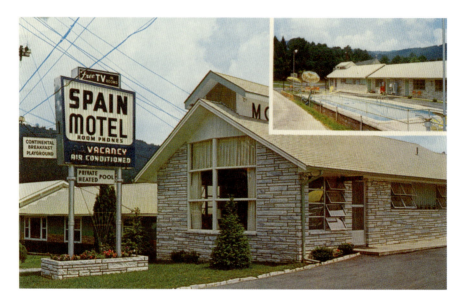

Courtesy of University of Tennessee, Knoxville–Libraries.

The Spain Motel, which was equipped with twenty-two modern units, was once located where the Courtyard by Marriott stands today. It's interesting to note that the Spain Motel, along with the Cloverleaf Motel and Colonial Motel, combined to form the Rocky Top Village Inn. In 1986, Felice and Boudleaux Bryant, owners of the Rocky Top Village Inn, expanded their establishment by acquiring the Spain Motel property. This expansion added a unique touch to the already thriving Rocky Top Village Inn.

CHAPTER 3
River Road

This may be the shortest chapter in the book, but River Road's lack of entries is due to the longevity of the businesses that have been established during the street's history. Initially a dirt path running along the Little Pigeon River, River Road has evolved over the years to become much more. Several tourist attractions throughout the road's history have left their mark—including Christus Gardens (later Christ in the Smokies),

which was open on River Road for over six decades—while the Peddler Steakhouse, established in 1976, and the Mysterious Mansion, established in 1980, are both still running strong. However, apart from the aforementioned attractions, the street is predominantly lined with accommodations that have stood open for years. The River Edge Inn, Edgewater Motel and River Terrace Motel have all been there since the late 1950s/early 1960s, and of course, we mustn't forget the legendary Gatlinburg Inn, which backs into a larger portion of River Road as well. As of this writing, the Hilton is the only chain-owned location on the street.

Although River Road has undergone less change than other streets in this volume, its ability to preserve a bygone era in a rapidly changing environment is a promising aspect that visitors should embrace. People who have been coming to the area for years have already discovered its charm and enjoy strolling along the riverside. Speaking of which, let's take a stroll down the river's edge and take a look at the few locations that have come and gone in River Road's history.

CONNER MOTOR LODGE

Claude Conner was a seasoned expert in the realm of successful motels. Prior to purchasing the Hagewood Motel, which he later renamed the Conner Motor Lodge, he had already owned and operated two other motels—the Park Tourist Court and Conner's Waterlure Motel—located on the opposite end of town. While much of the Hagewood's original design disappeared in the renovation process, some of its defining features remained, including the uniquely shaped pool and the iconic neon sign that shone brightly for years (albeit with a new name, of course). Unfortunately, Conner's Motor Lodge was demolished in the late 1990s to make way for the Bearskin Lodge on the River, which now stands at the corner of River Road and Ski Mountain Road. Keep reading to learn more about the Conners and their storied history.

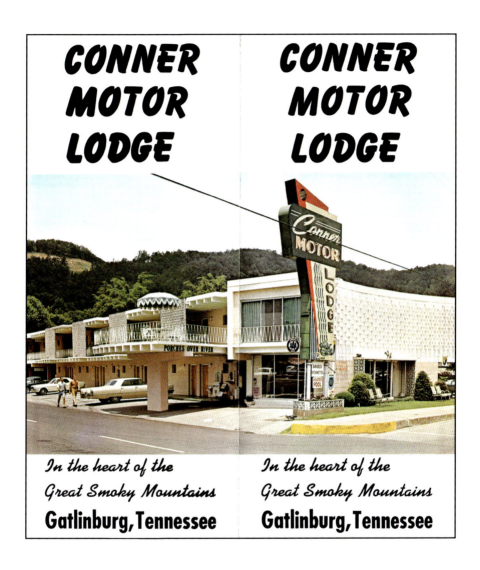

KING'S MOTEL

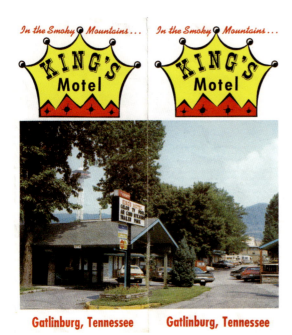

Otha and Mary Elva King purchased the land for King's Motel from Mary's father in the early twentieth century. Otha was a skilled builder who constructed motels. He started by building two units and eventually added more with the help of his son-in-law, an architect. The son-in-law drew up plans for more units on the sides, which were eventually added to the motel. Otha and Mary were known for their sense of humor but could be tough when necessary. They never retired and were always working at the motel, building a loyal customer base. Additionally, the King family opened King's Restaurant on the Parkway, which is now Howard's Restaurant. The building had previously served as a gristmill, weave shop and tavern known as King's Tavern. King's Motel was eventually sold and demolished in 2000, leaving a clean slate for the Hilton Garden Inn.

OGLE'S RIVER ROAD COURT

Before Winfred Ogle got his start in the motel business, he worked as a "doodler" in Andy Huff's sawmill. His job involved removing excess sawdust that had gathered below the blade by climbing under the sawmill. It was during this period that Winfred found his aspirations for motel proprietorship. By this time, Andy Huff's Mountain View Hotel (built in 1916) had already established itself as more than just a lodging for traveling lumbermen but also as the grandfather of Gatlinburg's countless motels, hotels and motor courts to follow. Although modest in size, Ogle's property featured a clean, contemporary design emblazoned in natural colors (as evidenced in this mid-'60s postcard) and remained a visitor favorite for many years. The Oak Square Condominiums currently occupies the space originally inhabited by Ogle's River Road Court.

RIVERHOUSE MOTORLODGE

The Riverhouse Motorlodge was a rustic retreat nestled against Crockett Mountain that offered a unique ambiance. Hugh Faust established the Riverhouse in 1971 and welcomed guests for over forty-five years until it was destroyed in the 2016 Gatlinburg wildfires. Sadly, it was the only property on the Parkway or River Road to be destroyed in the fires. Faust has continued

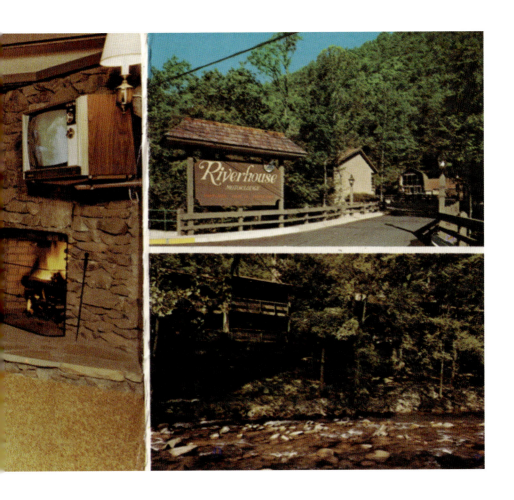

the tradition with its sister property, the Riverhouse Inn at the Park, which is still in operation. The Riverhouse Motorlodge will not be rebuilt, and the property currently sits vacant, although it is owned by the Skylift Park.

WADE'S MOTOR COURT

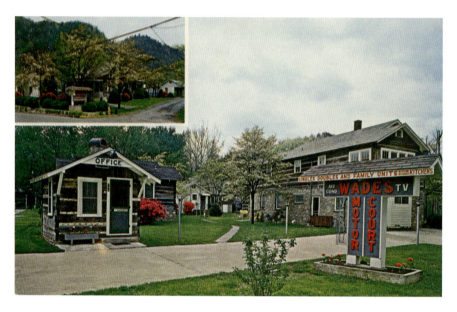

Courtesy of University of Tennessee, Knoxville–Libraries.

Otha and Bennie Wade most likely gained their hospitality know-how during their previous employment with the Mountain View Hotel, and it showed. Their motor court, located just two hundred yards from the Parkway by LeConte Creek and nestled away on River Road, not only exuded the mom-and-pop charm we all love but also provided an ideal spot for folks looking for a more relaxed experience. After many years of operation, the couple sold the property and relocated to Pigeon Forge. Although Wade's Motor Court is no longer standing, it once occupied the site where the River Edge Inn is now located.

CHAPTER 4
Highway 73

When I started commuting on Route 73 for work, I began to notice the incredible buildings lining the highway. During lunch breaks, I would admire landmarks like the Brookside Lodge, Sleepy Bear Motel and Carr's Northside Cottages and Motel, which are still in business today. However, I became increasingly curious about the history behind these landmarks of the past.

In my opinion, what sets Route 73 apart from Gatlinburg's other streets is the number of Hubert Bebb–designed properties that still exist within a short distance of one another. Bebb was one of East Tennessee's most celebrated architects, known for his unique style that blended traditional Appalachian architecture with modern design. His notable works include Clingman's Dome and the Sunsphere for the '82 World's Fair.

Over the years, State Route 73, also known as US 321, East Parkway and Roaring Fork Road (as the old-timers still refer to it), has amassed a substantial number of accommodations, establishing itself as the second-largest collection (after the Parkway) of lost motels in the area. If we want to continue our tour of vintage Gatlinburg, we should explore Route 73 by trolley, since this leg of the tour is more spread out. This scenic roadway will allow us to enjoy the cool mountain air and experience what Gatlinburg was like in its early days.

BUTLER MOTEL

Courtesy of University of Tennessee, Knoxville–Libraries.

The Butler Motel has truly stood the test of time, maintaining its original charm throughout the years. Its green exterior adorned with vibrant orange doors has changed; however, the structure still stands in all its vintage glory. In a bustling tourist destination like Gatlinburg, it's becoming increasingly rare to find a place that has managed to remain somewhat unchanged. The Butler Motel, now known as the Gatlinburg Village Condos, holds a special distinction in preserving its vintage charm amid the ever-changing landscape.

C & W APARTMENT MOTEL

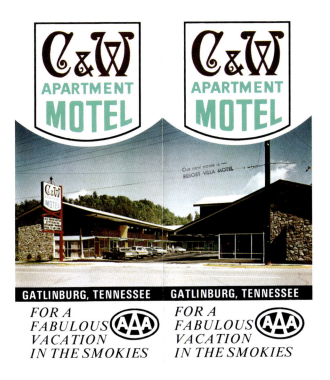

The C & W Apartment Motel offered a unique twist by providing both standard rooms and apartment rentals. These efficiency units became more popular over time, accommodating both long-term vacationers and those seeking temporary or permanent residence. The owners, Charles and Susie Lusk, along with James and Mary Lee Barnes, decided to rebrand the motel as the Resort Villa Motel, adding a touch of glamour to its name. This "home away from home" offered luxurious amenities such as heated pools, upscale furnishings and stylish decor, including wall-to-wall shag carpeting. Unfortunately, like all good things, the Resort Villa Motel eventually came to an end. Half of the rooms were converted into retail shops that are still in business today, while the other half, including the lobby, were demolished to make way for parking space.

CARVER'S MOTEL

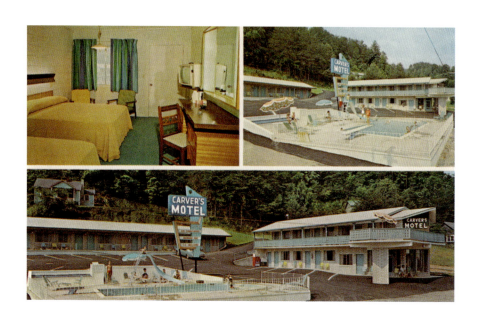

Roughly half of Carver's Motel was destroyed in the Gatlinburg wildfires of 2016. Unfortunately, none of the original structures seen in these pictures exist today, except for the pool area. The motel was divided by East Laurel Road, consisting of two parts: the original structures and the newer structures. The newer portion, now known as Country Town n' Suites, was thankfully spared during the fires and remains fully operational. After selling his motel in Gatlinburg, owner Luther Carver continued in the hotel/motel business with new ventures in Pigeon Forge. These include the Smoky Meadows Lodge (currently the Arbors at Island Landing Hotel and Suites) and Best Western Plus Apple Valley Lodge.

CREEKSIDE MOTEL

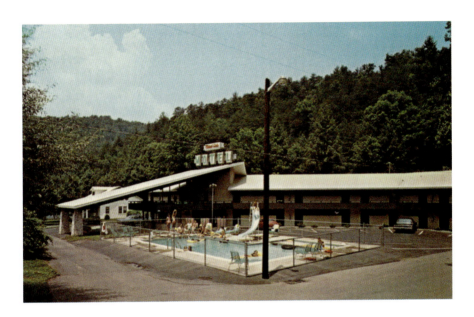

The Creekside Motel, situated off Highway 73, has maintained its original appearance throughout the years. This charming piece of Gatlinburg's history offered various amenities to please its patrons, including streamside porches, a heated pool, wall-to-wall carpeting, TVs, picnic areas and grills. Honestly, what more could you ask for? This "quiet and restful" motel, nestled along the picturesque Roaring Fork Creek, continues to operate as the Bear Creek Inn. You can find it on Sycamore Lane, just behind the Timber Ridge Lodge, formerly known as the East Side Motel.

CREEKSTONE MOTEL

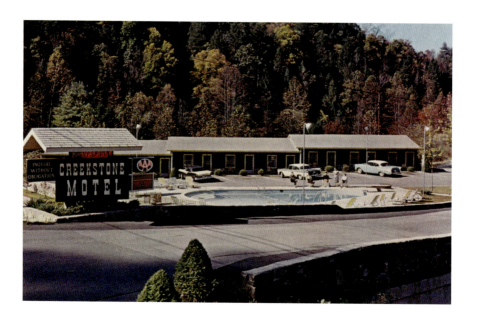

The Creekstone Motel holds a special place in Gatlinburg's history, representing the pioneering lineages of the town. Owners Jack and Mildred Ogle have deep family ties to the area, with ancestors who played significant roles in shaping Gatlinburg's early days. Mildred's great-grandfather Levi Trentham was a renowned storyteller, while Jack's great-great-great-grandfather Isaac "Shucky" Ogle was one of the town's first settlers. Unfortunately, the devastating wildfires of 2016 took a toll on these historic locations, leaving behind vacant land or new developments that lack the charm of their predecessors. The Creekstone Motel, with its twenty-two units and serene mountain stream, offered a quiet and cool retreat while providing easy access to the downtown district. Today, the original site of the Creekstone Motel has been transformed into additional parking for the First Baptist Church.

DEWEY-OGLE MOTEL

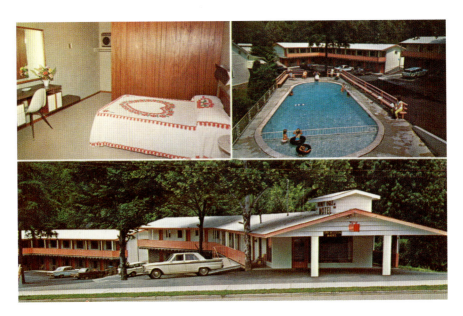

Courtesy of University of Tennessee, Knoxville–Libraries.

The Dewey-Ogle Motel, now part of the Brookside Resort, has remained structurally unaltered after all these years. In fact, an updated color scheme to match that of its neighbor appears to be the only noticeable change. As a result, the Dewey-Ogle Motel serves as a testament to the rich history of Gatlinburg and its vibrant tourism industry.

DOWNTOWNER MOTOR INN

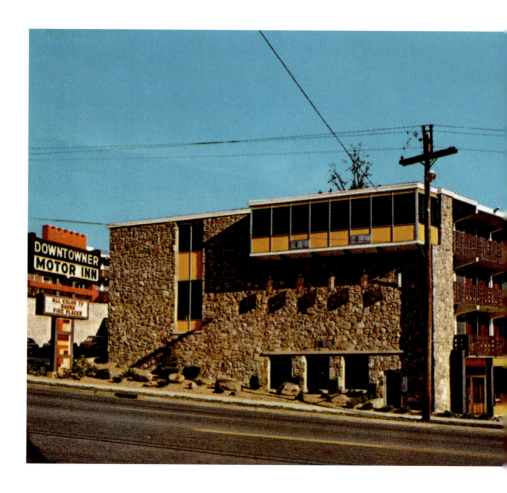

Jack Arthur Sr.'s response to losing everything in a near-fatal house fire was to build a motel. "My father had no previous motel experience but married into the genesis of Gatlinburg tourism. My mother (Nancy Huff) was the daughter of Andy Huff, builder, owner and operator of the Mountain View Hotel, Gatlinburg's first hotel. So the idea of building the Downtowner after the fire was sort of automatic," Jack Arthur Jr. explained. Jack Sr. chose to partner with the Downtowner Corporation, a Memphis-based chain of motels known for their economy-priced rooms strategically located in city centers. Jack's son, Douglas, managed the Downtowner's

day-to-day operations, which included sixty-eight rooms, the town's largest hydrotherapy built-in hot tub, a barbershop, a top-floor bar, a restaurant, a pool and a sauna. Although the property has remained largely unchanged, the Downtowner name has been replaced with the Parkview Inn and Suites.

DUDLEY CREEK MOTEL

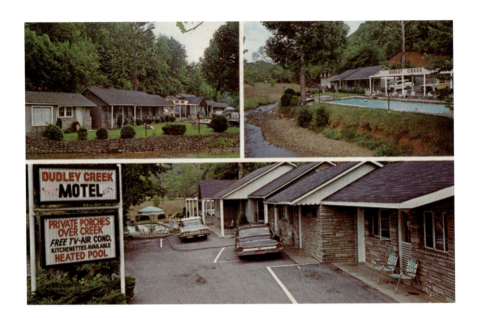

You can still spot the old-fashioned roadside stops along Highway 73 if you look closely. Nowadays, many of them have transformed into real estate offices, restaurants and various retail businesses. The Dudley Creek Motel, for instance, has become a long-term efficiency. Its ranch-style design consisted of two sections connected by landscaping, with a pool area and parking that stretched alongside Dudley Creek. The original structures, owned and operated by John D. Ogle Sr.; his wife, Roxie; and their son John Jr. have managed to withstand the test of time. However, the once-beautiful landscaping and swimming pool are a thing of the past.

EAST SIDE MOTEL

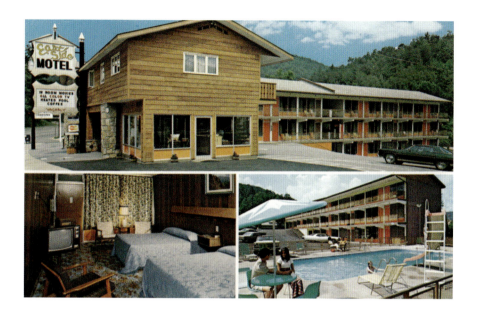

Marlene and Tom Trentham were well aware of the challenges they would encounter during the construction of their property in the early '70s. Tom had gained valuable experience from his parents, Virgil and Mattie Trentham, who were the proud owners of Virgil's Motel (established in 1958). "I'm incredibly proud of the business my parents worked tirelessly to establish. They managed the motel office, while we assisted with laundry and room cleaning. We even lived in a house connected to the motel, so they were available around the clock," recalls Nancy, the daughter of Tom and Marlene. The East Side Motel, which was completed in 1971, became one of Gatlinburg's most enduring motels. However, in 2023, the new owners decided to take the property in a different direction, and it is now known as the Timber Ridge Lodge.

FOX MOTEL

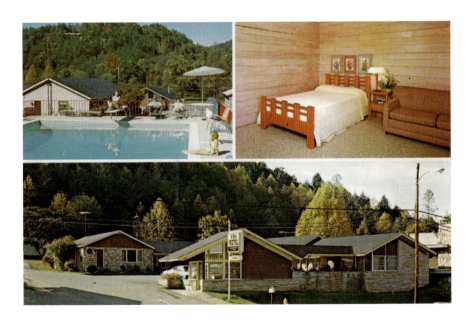

In 1951, a major flood destroyed a significant portion of Amos Fox's Pleasure Island Motel. As a result, he decided to sell the island and construct a new location in 1953, which eventually became the Fox Motel. Renowned local architect Hubert Bebb designed the motel, and apart from the addition of a staircase, it has largely remained unchanged over the years. Although the motel ceased operations in 1989, it was repurposed into a retail space. Throughout the years, it has housed various businesses, including a tattoo parlor and, currently, a salon and spa.

GATLINBURG COURT

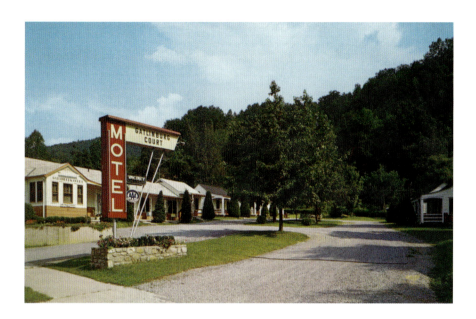

The Gatlinburg Court, owned by Mr. and Mrs. L.M. Giesen, operated on a quiet tract of Highway 73 during the '40s, '50s and '60s. In the early '70s, the property was purchased to build the first Tennessee State Bank. The motel office was temporarily used for banking operations until the branch was completed.

GREYSTONE MOTEL

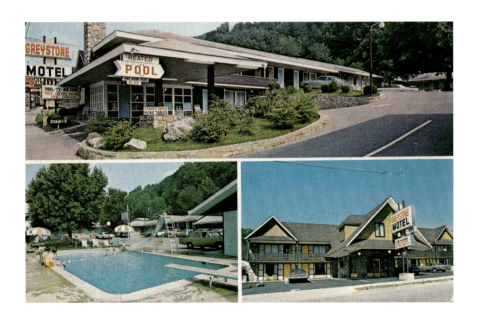

The Greystone Motel, not to be confused with the Hotel Greystone or the Greystone Lodge, was once located at 362 East Parkway. Technically, it still is, but these days it operates under a different name. As time went on, the motel expanded its reach. The Greystone Motel #2 was added directly across the street, catching the eye of vacationers and setting the two motels apart from the many other options available. Both buildings are still standing, along with other vintage structures on this stretch of Highway 73 (such as the Rainbow Motel, Fox Motel and Butler Motel). As of now, the Greystone Motel #1 is known as the E-Z Inn and Suites, while the Greystone Motel #2 has transformed into a pizza restaurant.

LAURELWOOD MOTEL

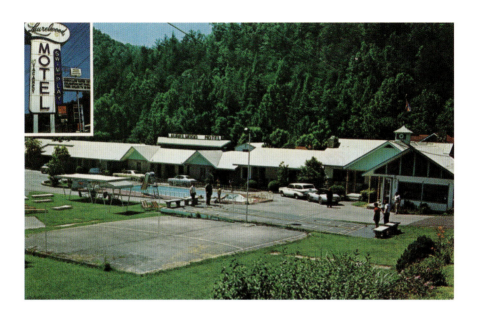

What began as cabins on Highway 321 eventually merged to form the Laurelwood Motel. When the highway expanded, Woody and Lela Luther had two choices: demolish the structures or move them to a central location (across from the Gatlinburg Chateau Rentals), combining them to create their own motel. Luckily, they chose the latter, and the Laurelwood Motel became a beloved part of Gatlinburg's hospitality scene for many years. Sadly, in the 2000s, the motel was demolished, and the land has remained vacant.

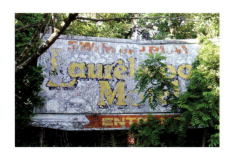

This Laurelwood Motel sign, once a welcoming sight inviting tourists to come swim and play, sadly spent its final years gradually getting buried under layers of underbrush. It was eventually removed in early 2023.

MOUNTAINEER MOTEL

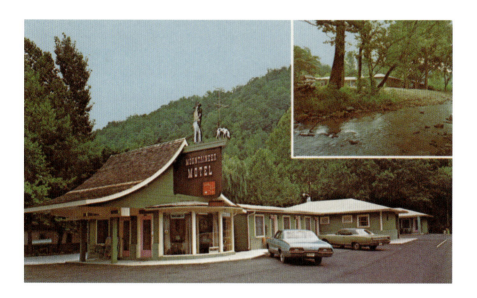

The Mountaineer Motel, with its brightly colored green exterior with pink trim and curved roof lobby, definitely caught people's attention. Originally known as the Mountain Air Motel and located on Airport Road, it was relocated to its current spot on Highway 73 when it was sold by the original owners, Hall and Ruth Sayles. Its proximity to downtown Gatlinburg and its picturesque location by a cool stream surely added to its appeal. Unfortunately, the Mountaineer Motel, which had been converted into an efficiency, succumbed to the Gatlinburg wildfires of 2016. The property, which was once next to the BB&T, remains vacant to this day, and now the BB&T has also closed.

OAK HILL MOTEL

It can indeed be challenging to gather information about specific locations like the Oak Hill Motel. From our research, we know that it was owned by W.M. Ogle, a local businessman, and was situated off Highway 73. Based on the knowledge of Gatlinburg native Randy Trentham, who is familiar with Ogle and his residence, it is likely that the motel was located in the same area. However, due to the lack of concrete evidence, we only have memories to rely on. Unfortunately, even memories seem scarce in this case.

OGLE'S VACATION MOTEL

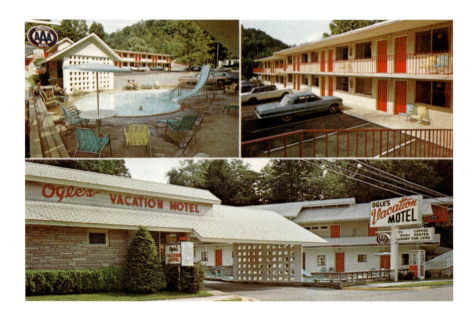

The Ogle family has a rich history in Gatlinburg dating to the early nineteenth century. Their influence on tourism is evident through establishments like Ogle's Buffet Restaurant, Ogle's Cafe, the Ogle General Store and Ogle's Water Park. Ogle's Vacation Motel, designed by renowned local architect Hubert Bebb, showcases mid-century design with clean lines, an angular roofline and bold colored accents. It was located just two blocks from the heart of Gatlinburg, and owner Charles R. Ogle paid attention to every detail. In the early '60s, renovations designed by Hubert Bebb further enhanced the motel's aesthetic appeal. Today, the motel has transformed into the Smoky Mountain Student Lodge, but its structural integrity remains intact.

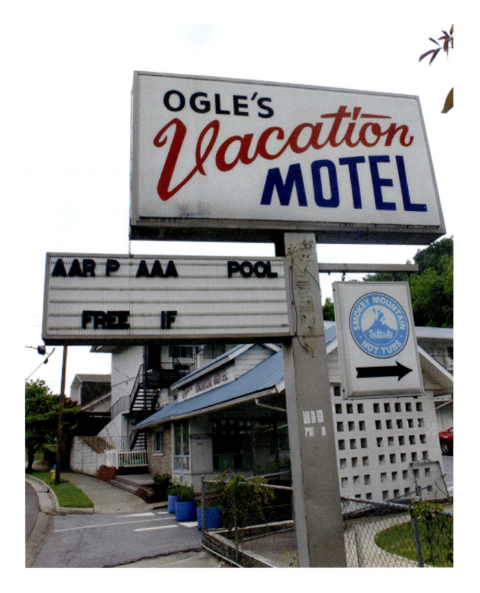

Before its transformation into the Smoky Mountain Student Lodge, the Ogle's Vacation Motel sign depicted in this photo showcased its previous appearance.

OWNBY'S MOTEL

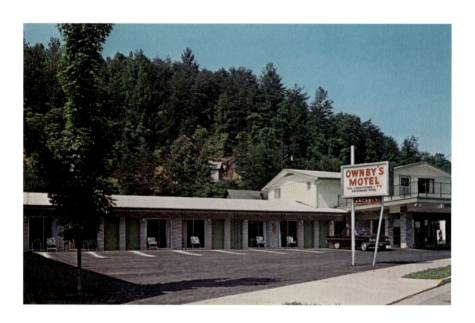

Ownby's Motel often gets overlooked in the area's history, but it compensates for its lack of impact with its remarkable ownership. Verlis Ownby was more than just a motel proprietor; he was a dedicated citizen, a World War II veteran, a skilled wood carver who sold his work locally and a retiree from the Great Smoky Mountains Park Service. He truly made his mark. Unfortunately, this split-level venture had become a thing of the past by the mid-'70s.

PINE CLIFF MOTEL

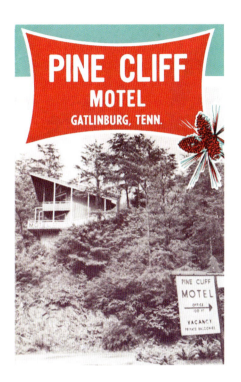

Ed Ogle Collection.

The uniquely designed Pine Cliff Motel, perched on a hilltop across from the current location of Alamo Steakhouse, had an interesting history. Virgil Ogle, the creator, didn't originally intend to venture into the tourism industry on his return from World War II. He worked various jobs, including at the national park, driving a taxi in Gatlinburg and managing his own gas station. In the late '50s, with the help of architect Hubert Bebb, construction began on the Pine Cliff Motel. The motel expanded over time, reaching a total of ten units, each featuring Bebb's distinctive sharply angled roof lines and regional materials. Virgil managed the motel until his semi-retirement in the late '70s. In the mid-'90s, the motel was leased and combined with Cupid's Chapel of Love, becoming Cupid's Love Nest Inn. Unfortunately, the motel fell into disrepair and was demolished in the early 2000s.

RAINBOW MOTEL

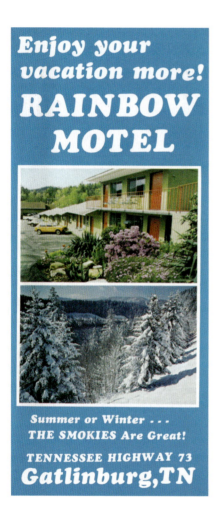

Eddie and Aline Trentham dedicated a significant portion of their lives to the Rainbow Motel, owning and operating it for many years. Eddie gained valuable experience managing the Twin Islands and Crossroads Motel before starting the Rainbow Motel. He worked tirelessly at the Twin Islands, seven days a week, from early morning until late at night. Prior to the Rainbow Motel, Eddie even raised honeybees and sold honey at the Twin Islands. Meanwhile, Aline worked as a waitress at Hobie Trentham's Little Brown Jug Restaurant in downtown Gatlinburg. The Rainbow Motel started with fifteen rooms, an office, a laundry room and living quarters around 1965. Over the years, the Trenthams added twelve more rooms and three cottages, which were moved from the Twin Islands Motel. After selling the Rainbow Motel, the Trenthams shifted their focus to running Rainbow Log Cabin Rentals. The original motel building is currently the Gatlinburg Mountain Inn.

ROCKY RIVER MOTEL

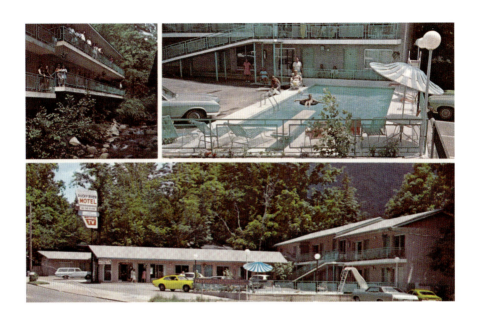

The Rocky River Motel, once nestled among the various options on Roaring Fork Road, sadly fell victim to the wildfires in 2016, along with several other establishments. The motel's advertising cleverly emphasized the allure of the nearby river, inviting guests to enjoy picnics and relax on the spacious patio by the water. The soothing sounds of the mountain stream were a prominent feature, making it a popular choice for visitors. The Rocky River Motel was located where Rocky Top Adventure UTV Rentals & Jeep Rentals stands today.

SKI-VIEW MOTEL

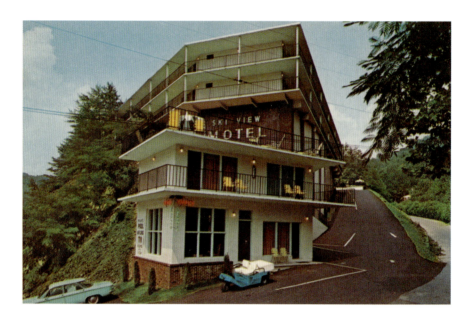

Before the construction of the Ski-View Motel, Charles E. Ogle, a local in Gatlinburg, was already deeply involved in the tourism industry. He curated locally crafted woven items for sale at the Arrowcraft Shop while also owning a grocery store on Highway 73. Charles also owned two hillside properties, including the Travelers Motel and this location at the corner of Highway 73 and Rattlesnake Hollow Road. Under Charles's care, the thirty-three-unit uniquely designed motel always boasted rooms with views of the Great Smoky Mountains National Park and the Gatlinburg ski slopes. Although the Ski-View is no longer under Charles Ogle's management and has changed its name, the location still stands, and structurally speaking, it appears that very little has changed.

SKYLAND MOTEL

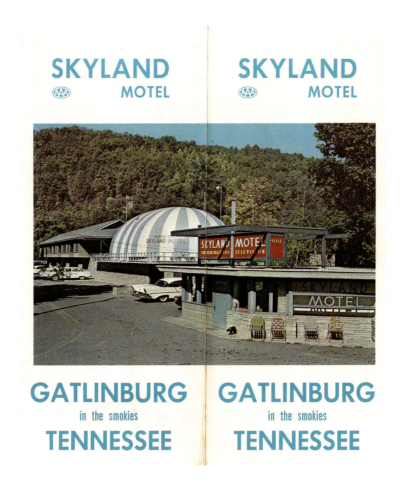

E.B. Reagan, along with his brother Von, had previous experience in the tourism industry with the successful Center Motel on the Parkway. When construction began on the Skyland Motel, Reagan's two-acre property with a stunning view of downtown Gatlinburg became a popular destination. According to Von Reagan Jr., E.B.'s nephew, the motel was consistently fully booked every year until the winter months. Over the years, the Skyland Motel expanded from 30 to an impressive 118 rooms before its closure in the late 2010s.

SLEEPY HOLLOW COURT

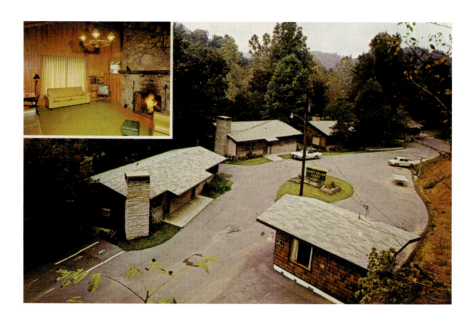

Sleepy Hollow Court was the epitome of seclusion with its dead-end street and the surrounding ten-acre forested track. Bill Burchfiel, the owner, truly understood the beauty of such a place, which is evident from the "vacation with complete privacy" slogan on every postcard. Even though Sleepy Hollow Road, where the court once stood, still maintains some seclusion, the unfortunate Gatlinburg wildfires of 2016 brought about the untimely demise of the property and its privately located cottages.

TRAVELERS MOTEL

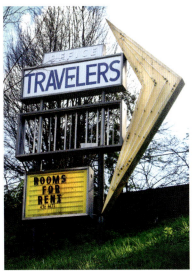

The Travelers Motel, which comprised upper and lower portions directly across the street from one another, belonged to local businessman Charles E. Ogle (the family has since sold the property). Unfortunately, the upper portions of the property were destroyed in the Gatlinburg wildfires, while the lower portion has continued as an efficiency rental (as of this writing). Initially, Charles used the lower tract of land for the grocery store he owned prior to his ventures in the motel business.

The Travelers Motel sign endures alongside the Trentham Place Shopping Center, weathering years after the upper structures were destroyed. Now surrounded by weeds and growth, this vintage neon beauty faces an uncertain fate, as the property is currently on the market.

VIRGIL'S MOTEL

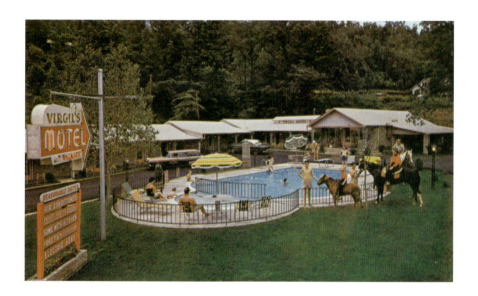

Virgil's Motel (built in 1955) was owned by Virgil and Mattie Trentham. They knew how to keep customers coming back year after year with accommodations for any group size and entertainment like pony rides and horseback riding for adults. The Trenthams' businesses also included a Texaco Station, which surely thrived as visitors filled up their tanks before venturing into the national park. Unfortunately, the motel closed its doors in 2006, making way for the Trentham Place Shopping Center that now occupies the property.

WILLOW MOTEL

Ruben and Pauline Reagan, who met while working at the Mountain View Hotel, tied the knot and ventured into the hospitality industry by establishing the Willow Motel in the early '50s. Starting with just four cabins, they later chose the name Willow after encountering issues with the cabin

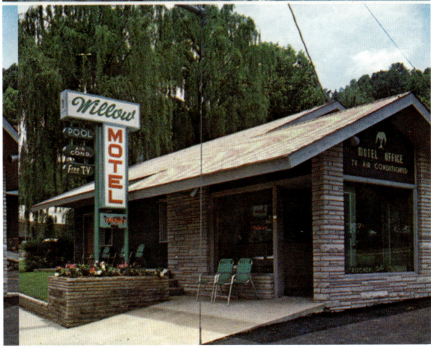

sewer lines due to the roots of a willow tree. In the early '60s, they took on the ambitious task of constructing a twenty-room motel, incorporating the distinct architectural style of Hubert Bebb with sharp angles and overhanging rooflines. After serving guests for several decades, the motel eventually closed its doors in the mid-'90s. Today, the property is home to Flowers of Gatlinburg, which operates from the motel's lobby.

WOODLAND MOTEL

The Woodland Motel, with its striking design and modern accommodations, was a testament to the skill of one of the area's top architects. It's hard to believe now, but back in the late '60s, you could rent a room for just eight dollars a night, or nine if you wanted a color TV instead of black and white. The land where the Woodland Motel once stood is now occupied by the Gatlinburg Sleep Inn & Suites.

CHAPTER 5
Baskins Creek and Beyond

Let's take a break from our journey and dip our feet in the cool, refreshing waters of Baskins Creek. As I curated entries for this collection, I realized that the best way to organize it was to break it down into chapters based on the most popular streets in the area's history. However, it was clear that I needed a chapter that encompassed not only the heavily equipped

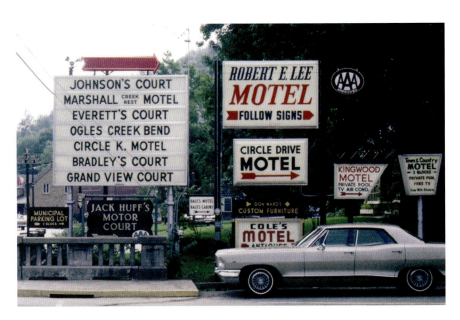

accommodations but also the less popular ones. Thus, chapter 5, "Baskins Creek and Beyond," was born.

When discussing Baskins Creek, it's easy to jump right into the plethora of bygone lodgings that have come and gone over time. However, there's a story in its history that is rarely told: how the name "Baskins Creek" came to be. The name doesn't derive from any local or regional hero but rather from an event that occurred. Hunters from Knoxville came into town, hunting for bears, and after a successful hunt, they skinned their bears, leaving the skins by the creek until they could retrieve them. Locals originally referred to the creek as Bearskins Creek, but over time, the name evolved and became Baskins Creek as it was adopted into the regional vernacular.

Now that you know that little tidbit of local lore, let's dive into this chapter. As mentioned previously, we won't be hanging around just Baskins Creek but also several of Gatlinburg's side roads, where vintage motels once thrived. So sit back and relax as we, appropriately, start things off on Baskins Creek Road (or Bearskins Creek Road, if you prefer).

BALES MOTEL

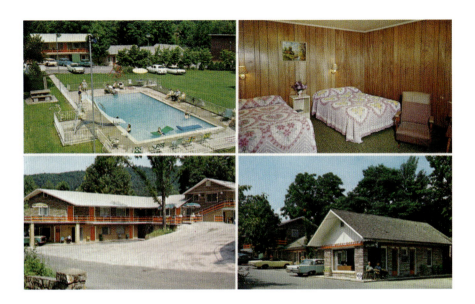

Homer Bales built the Bales Motel in 1959, which at the time consisted of five rooms. He spent most of the '50s maintaining Bales' Cabins (eleven cabins located on Baskins Creek), while his wife, Pearl, maintained the couple's restaurant, Bales Cafe. When the café's long hours began taking a toll on Pearl, Homer began construction on the first half of the motel (located on Bishop Lane), solely for Pearl to own and operate. A second half was built on Newton Lane, which Homer operated himself, while their son and daughter-in-law maintained the cabins. The "separate Bales Motels hooked up in the middle but were two separate businesses and two separate bank accounts," recalls their grandson Stephen Lyn Bales. In subsequent years, Homer expanded both properties to include more rooms, but they remained separate until the end. The properties remained within the family for many years, with various members carrying out the management duties. Furthermore, both structures survived the wildfires that took place in November 2016, while many of the surrounding businesses were destroyed. As of this writing, the properties have been permanently closed.

BALES' CABINS

Homer and Pearl Bales, like many others at the time, sold their property (127 acres for $2,250) during the establishment of the Great Smoky Mountains National Park. However, they saw an opportunity in Gatlinburg's growing tourism industry and didn't let the park's developments hold them back. With Pearl's business sense and Homer's carpentry skills, they opened Bales Cafe in 1949. While Pearl served delicious biscuits and blackberry dumplings, Homer built eleven cabins along Baskins Creek called Bales' Cabins. The cabins were completed in 1952, and Homer managed them until his retirement in the mid-'70s. Russell and Helen, the Bales' son and daughter-in-law, took over the day-to-day operations and continued the family business for the next twenty years. The cabins eventually closed in 1996.

BON-AIR MOTEL

In 1953, businessman Bon Hicks Sr. hired the Knoxville architectural firm Painter, Weeks and McCarty to design his motel. The completed eighteen units, with their ultramodern design, proved very desirable among tourists, maintaining a 99.6 percent occupancy rate during the motel's first 150 days in business. Guests climbed a sixty-degree access road, meandering along gray mountain stone retaining walls, to reach the two-story hilltop motel. The Bon-Air Motel was considered one of the top motels in Gatlinburg, earning recognition in *Architectural Forum* and various design awards. The motel, along with its sister property Holiday Hill Motel, has long since been removed, but the sixty-degree access road (now Bon-Air Drive) remains. Additionally, it is worth noting that Bob Hicks Sr. also founded Cash Hardware, a historic establishment in Sevierville, Tennessee, since 1929.

BRADLEY'S COURT

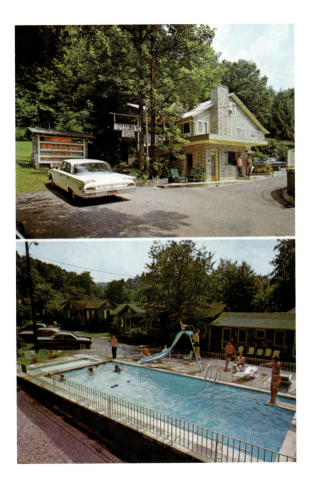

Sevier County native Carl Bradley, along with his wife, Dicie, owned and operated Bradley's Court, nestled snugly at the end of Wolliss Lane, for well over fifty years. Carl and Dicie's son Chuck eventually took over ownership of the seventeen units, while subsequently taking office as mayor of Gatlinburg in the '90s. Like many of the entries found within this volume, Bradley's Court succumbed to the destruction of the indiscriminate Gatlinburg wildfires of 2016.

BUFORD'S COURT

Courtesy of University of Tennessee, Knoxville–Libraries.

The Reagan family, just like the Ogles, Huffs and Whaleys, were pioneers in developing Gatlinburg's tourism in its early years. Buford Reagan chose to continue the family trade by contributing Mountain Manor (Airport Road) and Buford's Court, which was located on the banks of Roaring Fork Creek. Fortunately, we have this image from around 1957 that gives us an idea of how the property looked in all its glory. These days, you'll find the Greystone Cottages sitting where the court once stood.

CIRCLE K MOTEL

The Circle K Motel was completed in 1964 and named after Bill and Mary Alice Cox's four children, all of whose names begin with the letter K. The property, which had twenty-four units, is still located at the corner of Newton Lane and Cherokee Orchard Road. Before this project, in the late '50s, Bill and Mary Alice had built the Moonwink Cottages, a group of cabins along Baskins Creek, just a block away from the Circle K Motel site. The Huff family, considered the founding family of Gatlinburg's motel industry, took advantage of the '82 World's Fair in Knoxville, Tennessee, by constructing a new location. This new establishment, called Mountain House Motor Inn, was situated directly behind the Circle K Motel and operated separately until 1993, when the Huff family leased the building from the Coxes. They combined both properties into one, creating the Mountain House Inn.

COLE'S MOTEL

This charming piece of Gatlinburg's history wasn't just a motel; it also housed an antique shop. Homer and Maude Cole, the owners, ingeniously utilized the motel lobby to showcase and sell vintage treasures while efficiently managing check-ins. Tragically, the 2016 wildfires ravaged the original lobby as well as the individual units located at the corner of Stephen Drive and Newton Lane.

COLONIAL MOTEL

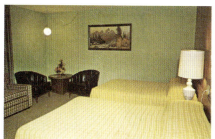
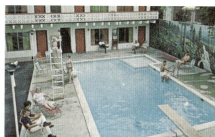
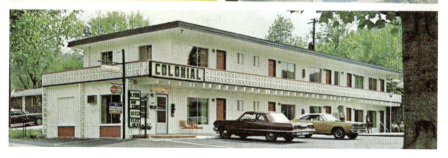

For decades, Airport Road has been a buzzing hub for hotels, motels and motor courts. Among them, the Colonial Motel, though technically on Reagan Drive, was nestled right in the mix. Ruth and Andrew Grizzle were the proud owners and operators, with Ruth being a retired schoolteacher from the Anderson County school system. Over time, the annexation of the Colonial, Spain, and CloverLeaf Motels paved the way for the creation of Rocky Top Village Inn on Airport Road. Unfortunately, in 2014, the structures of the Colonial Motel and the rest of Rocky Top Village Inn were demolished. Today, the entire plot of land is occupied by a Courtyard by Marriott.

EVERETT'S COURT

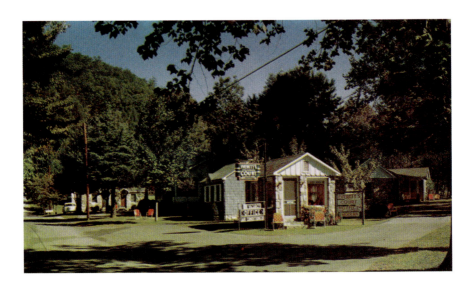

Opportunity came knocking when Riverside Motor Lodge owner/operator Stephen "Uncle Steve" Whaley divided a large portion of the seventy-five acres he bought from Richard R. Ogle in 1917. This gave Everett and his wife, Laura Trentham, along with others, the chance to seize that opportunity. The modern cottages along Wolliss Lane, Baskins Creek Road and Stephen Drive served as the foundation for Everett's Court, which stood for many years before being sold for future developments. This piece of land, located just two blocks from the town center, is now home to Baskins Creek Condominiums.

GRAND VIEW COURT

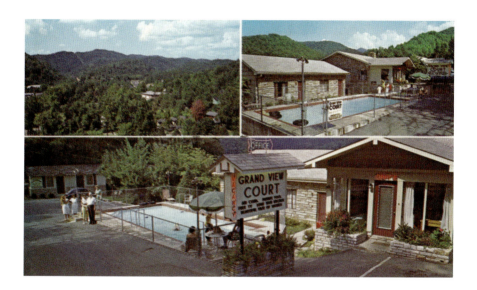

Nestled atop East Holly Ridge Road, this property boasted an awe-inspiring vantage point, making the task of naming it a breeze. Grand View Court, owned by Mr. and Mrs. Earl Lawson, may not have been the largest establishment we've discussed, but bigger isn't always better. With just eleven meticulously maintained units, it offered a contemporary and secluded retreat. Tragically, both the Grand View and its neighboring Robert E. Lee Motel fell victim to the devastating 2016 wildfires, leaving behind vacant lots for both.

HAGEWOOD MOTEL

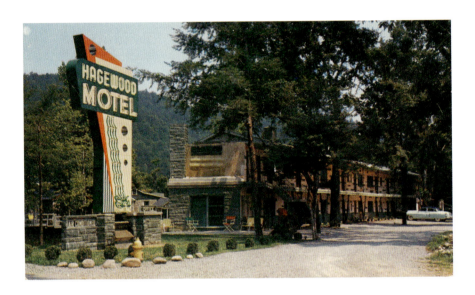

Lorris and Josephine Hagewood successfully left their mark on Gatlinburg's tourism industry, not only in motels but in women's accessories as well. During the '50s, the couple owned not only the Supreme Motor Court and Hagewood's Pigeon River Cabins but also the subject of this entry, the Hagewood Motel. The masonry used in the design was Florida coquina and Virginia greenstone, and all twenty-one rooms featured a private veranda overlooking the Little Pigeon River. Lorris, an avid sports enthusiast, was sure to add activities such as horseback riding, while Josephine began selling her patented, hand-loomed nylon bags and providing demonstrations for the motel guests using her loom. The property was sold to Claude Conner and, for many years, operated under the name Conner Motor Lodge. These days, you'll find the Bearskin Lodge on the River where the Hagewood Motel would have been located.

HARRISON'S NESTLE INN

Courtesy of University of Tennessee, Knoxville–Libraries.

Bob and Frances Harrison's Nestle Inn truly lived up to its name, nestled along the serene edge of Baskins Creek. Its tranquil location, beautifully designed rooms and convenient access to town made it a beloved choice for visitors for nearly fifty years. However, in 2016, tragedy struck as the Gatlinburg wildfires claimed the inn, then known as the Baskins Creek Nestle Inn, along with nearly 2,500 other buildings. It was a heartbreaking loss for the community.

HOLIDAY HILL MOTEL

In 1952, the Holiday Hill Motel was built on a hillside adjacent to the Parkway in Gatlinburg, Tennessee. The ranch-style motel boasted spacious, home-like rooms and private porches that overlooked the surrounding ridge. Over the years, the motel changed hands multiple times, with one owner being Tom Windrom, the architect who designed Christus Gardens in the early 1960s. The last owners of the motel were the owners of the Bon-Air Motel, who operated both properties until they were both demolished in the 1980s to make way for the Summit Manor Condominiums.

HOMESTEAD HOUSE

Owner Ed Whaley knew a thing or two about the motel business, and the Homestead House was not only one of the finest examples of his know-how but also another remarkable addition to the Whaley legacy. Built in 1982, this eighty-five-room giant had it all. In fact, it's rumored that legendary musician Prince stayed there, along with the principal owner of the New York Yankees, George Steinbrenner. The riverside terrace, running along the banks of the Little Pigeon River, offered one of the property's most striking amenities—a stone-paved walkway surrounded by floral gardens and a connecting tennis court. Currently, it operates as a Quality Inn and Suites.

HOWARD JOHNSON'S MOTOR LODGE

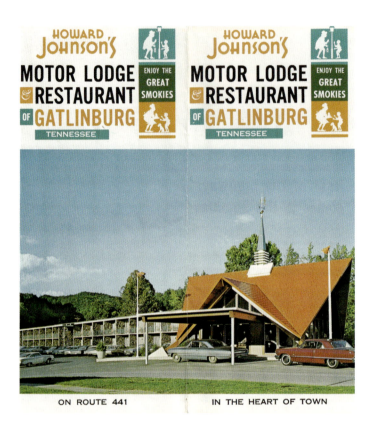

The Gatlinburg "HoJo," featuring all the classic design trademarks of the time, was located on what is known today as Greystone Heights Road. However, it wasn't the first motor court built on the site; Lay's Court, also at one time known as Town Court, a motor court consisting of twenty-one cottages, occupied the land during the 1940s and '50s. These days, you'll find the Greystone Lodge on the River where the HoJo Motor Lodge once stood, with No Way José's Cantina operating in place of the original restaurant. Both the Greystone Lodge and No Way José's utilize the original structures from the motor lodge and restaurant. Howard Johnson's hotels and motels are now part of Wyndham Hotels and Resorts, but sadly, the orange roofs, weather vanes and aqua motifs, which have become iconic symbols of the American roadside, are now a thing of the past.

HUSKEY'S CIRCLE DRIVE MOTEL

Circle Drive was not a conventional spot for lodgings; in fact, this location is the only one featured in this volume. Nevertheless, Husky's Circle Drive Motel, located a stone's throw from downtown, was described as being in the heart of the Great Smokies with cool and quiet surroundings. The '50s-style rancher had six rooms, but owners Earl and Opal Huskey made up for its size with their hospitality. According to Karen Huskey McReynolds, their granddaughter, "They were very loving people. My grandfather had a construction crew while my grandmother ran the motel, and I would help her in the summer." The Huskeys also rented out their home as additional accommodations when the city was full. The motel was eventually sold and converted to apartments, but sadly, the 2016 wildfires leveled the property, leaving the land vacant.

JOHNSON'S INN

In 1946, sisters Hettie and Lura Ownby established Johnson's Inn, a Gatlinburg landmark that spanned more than three generations. They, along with Hattie Ogle McGiffin, owner of Bearskin Motel, were trailblazers in Gatlinburg's motel industry and were acknowledged as such in the community. Hettie's daughter-in-law, Dorothy Johnson, fondly recalls, "Hettie and Lura were best of friends and workaholics. It's like they were glued at the hips." The business-savvy sisters initially constructed cabins and eventually added a full-fledged motel with twenty-four rooms. In the '90s, they completed a four-story building with an additional forty-eight rooms. The property was sold in the 2010s and is now known as Howard Johnson by Wyndham Downtown Gatlinburg.

KINGWOOD MOTEL

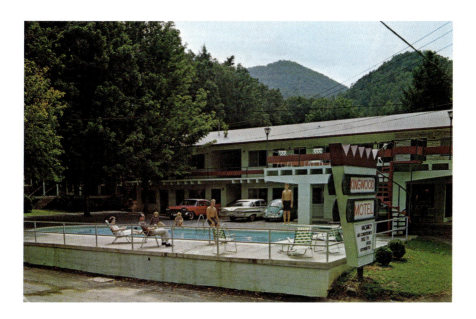

According to Clell King, he was aware that if and when he returned home from his service in World War II, there was a good chance he would pursue a career in preaching. Well, he did make it home, and he did become a preacher. In fact, he spent the next thirty-two years of his life preaching throughout most of East Tennessee. Fortunately, Clell not only spread the good word but also built the Kingwood Motel in the '50s. It was a beautiful location at the corner of Bishop Lane and Stephen Drive, with forty-plus rooms and a private pool. It was considered one of Gatlinburg's finest. Sadly, it was destroyed in the Gatlinburg wildfires of 2016. As of now, the property remains vacant.

MERRITT MOTEL

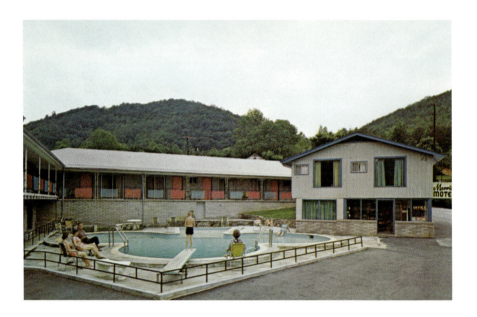

Back in the 1950s, Charlie Merritt relocated from Roseville, North Carolina, to Gatlinburg, Tennessee. While Charlie worked as a skilled bulldozer operator for Taylor Construction, he and his wife, Laura Whaley, saved up enough money to embark on their own entrepreneurial journey. They established the Merritt Motel, where they not only operated the business but also called it their home. After they sold the motel, it underwent a series of transformations, becoming the Grand Prix Motel and eventually the Ski Mountain Lodge.

NEW ALPINE MOTEL

"Every room with a mountain view," claimed the owners of the New Alpine Motel—and, as it was situated just beneath Mt. Harrison, it's safe to say that their statement held true. This beautifully designed motel, conveniently situated below the Gatlinburg Ski Resort (now known as Ober Mountain), offered guests not only breathtaking views but also easy access to the slopes. Today, the motel continues its legacy as the Econo Lodge Inn & Suites on the River. Although it may have lost some of its mid-century charm, it's wonderful to see that one of Gatlinburg's older structures is still holding strong.

OAKLEY MOTEL

Ed Ogle collection.

Oakley Motel was a small property located on Ski Mountain Road, under the ownership of David C. and Joann Oakley. The couple's influence within the community expanded further than the motel, as David was a World War II veteran and a ski instructor at the Ober Gatlinburg Ski Resort, while Joann was the art teacher at the elementary school. Also worth noting is that David's father, Wiley Oakley, who was known as the "Roamin' Man of the Mountains," was an explorer, mountaineer and legendary Smoky Mountains tour guide. In subsequent years, the motel was closed and remodeled, making space for various retail shops as well as a pizza restaurant. Sadly, the property, along with the Oakleys' house (which sat above the motel), was destroyed in the wildfires of 2016.

OGLE'S CREEK BEND CABINS

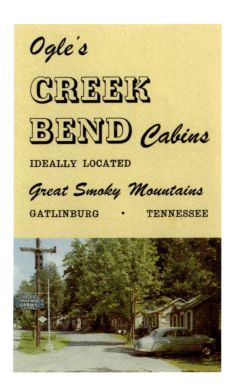

Ogle's Creek Bend Cabins, nestled away from the city's hustle and bustle, offered a peaceful retreat while still being conveniently accessible. Owner Mrs. Elder Ogle poured her artistic talents into the property, creating an authentic mountain experience and treating guests like family. The cabins were adorned with Mrs. Ogle's handcrafted window drapes, rugs, mantelpieces, bedspreads and furniture made by local artisans. Situated in a bend of Baskins Creek at the intersection of Baskins Creek Road and Circle Drive, the cabins have been replaced by monthly rental units, still occupying that beautiful stretch of mountain land.

OGLE'S PIGEON RIVER CABINS

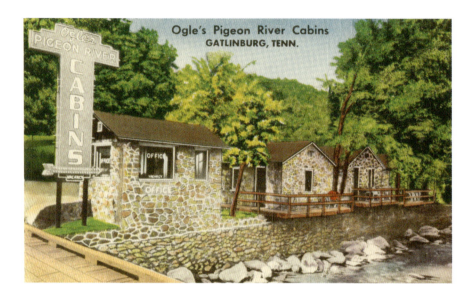

The Ogle's Pigeon River Cabins were the last accommodations before entering the Great Smoky Mountains National Park when they were initially constructed. However, in the early '50s, Lorris and Jo Hagewood, the owners at the time, constructed an additional property called Hagewood Motel across the river—technically making it the last accommodations before entering the park. During their ownership of the cabins, the name was changed to Hagewood Pigeon River Court and Motel. While fishing from your cabin balcony is no longer possible, you can still enjoy a riverside stay at the SureStay Plus Hotel by Best Western, which now operates where the cabins once stood.

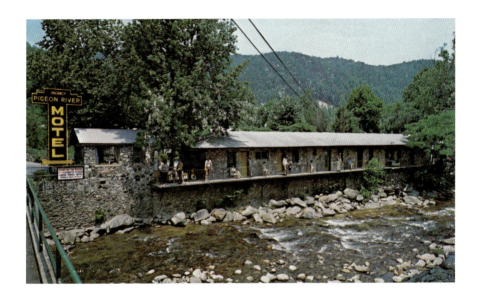

In the '70s, new owners took over Ogle's Pigeon River Cabins and renamed the property Pigeon River Motel. They not only changed the name but also renovated the property, expanding the eighteen individual units into a full-fledged motel with twenty-eight rooms that overlooked the beautiful river.

REAGAN MOTEL

In the heart of Gatlinburg, more specifically Reagan Drive, stood Stuart Reagan's suitably titled Reagan Motel (not to be confused with Reagan's Motel). Undoubtedly taking cues from his mother, Barbara Reagan, a headstrong businesswoman and motel operator as well, Stuart conducted business in a similar fashion, offering all the modern conveniences required to remain competitive within the industry. It's interesting to note that the property also had a stint as a retail space, known as the Mall. Despite this unique history, the motel has remained virtually unchanged and now operates as an Econo Lodge.

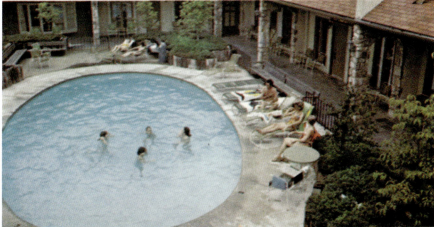

ROBERT E. LEE MOTEL

Courtesy of University of Tennessee, Knoxville–Libraries.

This property, just like its neighbor, the Grandview Court, offered stunning views of Gatlinburg from its location on top of East Holly Ridge Road. While it had all the modern amenities to stay competitive, this motel excelled in old-fashioned charm and southern hospitality. The owners, Robert and Eva Brown, were well-known in the community, not just for their hospitality business but also for owning Bob Brown's Garage, an ESSO station on the left as you entered the city limits from Pigeon Forge. The Robert E. Lee maintained its mountain appeal for over four decades. In fact, the property's Facebook page summed it up perfectly: "The way it used to be, the way it ought to be, the way it is!" Unfortunately, the property has remained vacant since the wildfires of 2016.

SMOKY PINES MOTEL

After owning and operating two fast food establishments and one small motel in Ohio, Walt and Elizabeth Leiser relocated to Gatlinburg, Tennessee, in 1980. There, they owned and operated the Smoky Pines Motel for twenty-seven years. Their property, situated on Baskins Creek Road, encompassed motel units, cabins and fully furnished group homes. The original office building, along with six units of the Smoky Pines Motel, has an intriguing backstory. It was originally part of the Gillette Motel on Airport Road, prior to the construction of its new wing. Unfortunately, the cabins and group homes were tragically destroyed in November 2016 during the devastating Gatlinburg wildfires. As of now, the motel offices and units still exist, but they are not currently operational.

SUPREME MOTOR COURT

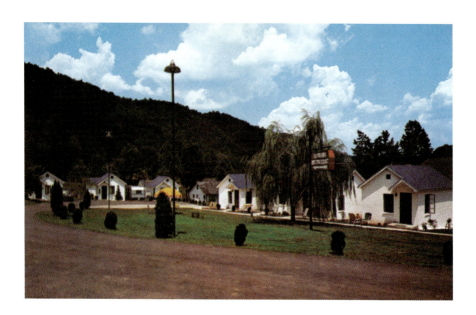

During the 1950s, tourists exploring Ski Mountain Road (previously known as Ownby Street) would have come across a trio of establishments owned by Lorris and Jo Hagewood. These entrepreneurs managed three locations: Supreme Motor Court, Hagewood's Pigeon River Cabins and the Hagewood Motel. Situated along the Cliff Branch of the Little Pigeon River, the Supreme Motor Court boasted ten stucco masonry units with meticulously maintained lawns, showcasing Lorris and Jo's commitment to providing exceptional hospitality. Not limited to the hospitality industry, the dynamic duo also established a successful handbag company, selling thousands of their stylish creations.

TOWN AND COUNTRY MOTEL

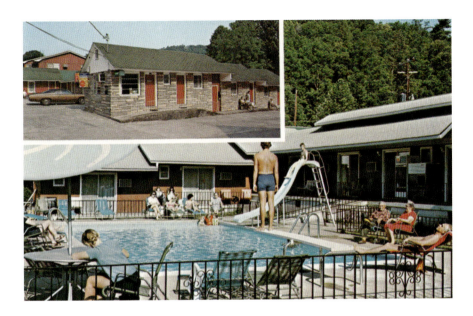

The Bales family name has undoubtedly made its mark on Gatlinburg's history over the years. Homer and Pearl Bales started Bales Cabins in the '40s and later founded Bales Motel in the '50s. Their son Rubin, along with his wife, Micki, constructed the Town and Country Motel in 1954. Their twelve-unit, single-story accommodations were once located at 127 Newton Lane (currently a vacant tract of land). Rubin and Micki owned and operated the motel until their retirement in 1990. It's interesting to note that Rubin also worked as a movie projectionist, a skill he acquired during his service in World War II in Okinawa.

WATSON'S MOTEL

Herbert and Georgia Watson, owners of Watson's Motel, promised to fulfill their guests' preferences with options ranging from individual cottages to modern motel units. The motel underwent renovations and expansions in '64, '66 and '71, thanks to architect Hubert Bebb, in the Watsons' quest to provide "vacation living in a modern way." The motel's location just one block from the Parkway offered a unique view of the tram as it traveled up the mountainside. Although the motel's structures were long since defunct, a wildfire destroyed them in 2016.

Bibliography

Aiken, Gene. *Mountain Ways*. Gatlinburg: University of Tennessee Press, 1983.

Atchley Funeral Home. "Charles Edwin 'Ed' Whaley." December 19, 2017. https://www.atchleyfuneralhome.com/obituaries/Charles-Edwin-Ed-Whaley?obId=2825247.

Bearskin Lodge. "History of Bearskin Lodge." https://www.thebearskinlodge.com/history-of-bearskin-lodge/.

Bluegrass Cabin Rentals. "Gatlinburg Restaurant Guide." https://www.gatlinburg-cabinrental.com/Restaurants.html.

Davis, Harold. "Harrison's Nestle Inn Circle Drive, Gatlinburg, Tenn." Postcard in the collection of the University of Tennessee, Knoxville–Libraries.

Davis, Harold H. "Spain Motel Airport Road Gatlinburg, Tenn." Postcard in the collection of the University of Tennessee, Knoxville–Libraries, 1967.

Hollis, Tim. *Lost Attractions of the Smoky Mountains*. Charleston, SC: The History Press, 2019.

Knoxville News Sentinel. "Gene Vaughn Obituary." August 31, 2005. Accessed via Legacy.com. https://www.legacy.com/us/obituaries/knoxnews/name/gene-vaughn-obituary?id=14026969.

Maddox, Marie. *A Lifetime in Gatlinburg: Martha Cole Whaley Remembers*. Charleston, SC: The History Press, 2014.

BIBLIOGRAPHY

Matheny, Jim. "Riverhouse Owners Burned Twice by Fall Wildfires." WBIR, November 30, 2016. https://www.wbir.com/article/news/local/riverhouse-owners-burned-twice-by-fall-wildfires/51-364322073.

McMahan, Carroll. "Upland Chronicles: Gatlinburg's Luther 'Coot' Ogle a Self-Made Man." *Mountain Press*, September 24, 2012.

————. "Upland Chronicles: Riverside Hotel Has Reached Its Final Days." *Mountain Press*, June 2, 2013.

Osborn, Rachel. "Memories of Midtown." *Mountain Press*, January 1, 2012.

Russell, Tony. "Felice Bryant." *Guardian*, May 19, 2003. https://amp.theguardian.com/news/2003/may/20/guardianobituaries.artsobituaries.

Tribute Archive. "Mildred Trentham Ogle Obituary." August 12, 2014. www.tributearchive.com/obituaries/2559610/Mildred-Trentham-Ogle.

The Vintage Purse Museum. "Jo Hagewood Woven Drawstring Handbag." June 21, 2020. https://vintagepursegallery.blogspot.com/2020/06/jo-hagewood-woven-drawstring-handbag.html?m=1.

Wikipedia Contributors. "Holiday Inn." Retrieved 18:25, August 8, 2023, from https://en.wikipedia.org/wiki/Holiday_Inn.

W.M. Cline Company. "Bufords Court Roaring Fork Road Gatlinburg, Tennessee." Postcard in the collection of the University of Tennessee, Knoxville–Libraries, 1957.

————. "Butler Motel (Hwy. 73) Roaring Fork Road Gatlinburg, Tennessee 37738." Postcard in the collection of the University of Tennessee, Knoxville–Libraries.

————. "Dewey Ogle Motel Gatlinburg, Tennessee." Postcard in the collection of the University of Tennessee, Knoxville–Libraries.

W.M. Cline Company and Gene Aiken. "Robert E. Lee Motel Gatlinburg, Tennessee." Postcard in the collection of the University of Tennessee, Knoxville–Libraries.

————. "Wades Motor Court on River Road Gatlinburg, Tennessee." Postcard in the collection of the University of Tennessee, Knoxville–Libraries.

About the Author

Brian M. McKnight, along with his wife and daughter, have made Sevierville, Tennessee, their hometown. Brian has created several documentaries for local events and made valuable contributions to exhibits, including the renowned A Home for Our Past: The Museum of East Tennessee History at 25. His first full-length documentary, *The Last Wolf: Karl Edward Wagner*, has been screened in twenty-seven countries. And now, with *Lost Motels of Gatlinburg* as his debut book, he's eagerly looking forward to publishing more in the future.